The Bird, the Banner, and Uncle Sam

Also by Elinor Lander Horwitz

The Bird,
the Banner,
and Uncle Sam

Images of America
in Folk and Popular Art

ELINOR LANDER HORWITZ
J. Roderick Moore, Consultant

J. B. Lippincott Company / Philadelphia and New York

The author wishes to thank the following people for their advice and assistance: Elsa M. Bruton, Dr. and Mrs. Louis C. Jones, Herbert W. Hemphill, Jr., Anna Wadsworth, and Julia Weissman.

The photographs on pages 61, 70 top, 98 are reproduced from *American Folk Sculpture* by permission of E.P. Dutton & Co., Inc.

U.S. Library of Congress Cataloging in Publication Data

Horwitz, Elinor Lander.
 The bird, the banner, and Uncle Sam.

 Bibliography: p.
 Includes index.
 SUMMARY: Discusses the patriotic symbols and heroes of the American people and their use in past and present art and craft objects.
 1. Folk art—United States. 2. Symbolism in art—United States. 3. United States in art. [1. Folk art—United States. 2. United States in art] I. Title.
 NK805.H69 745'.0973 76-16492
 ISBN-0-397-31690-9 ISBN-0-397-31691-7 (pbk.)

This book is dedicated

to Joshua, who was born on Washington's birthday,

and to Jenny, who was not.

Contents

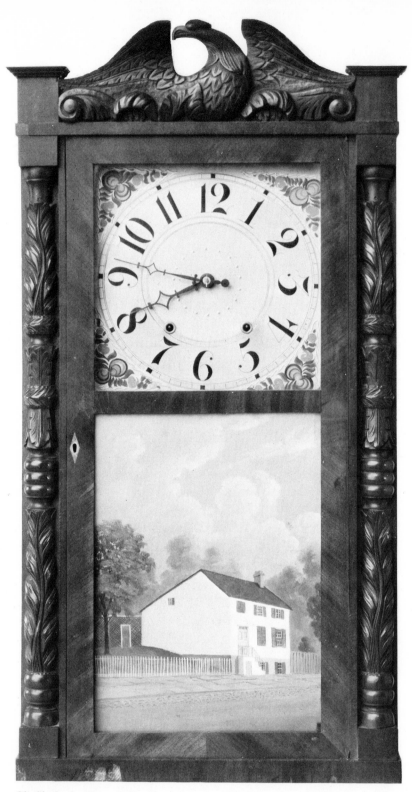

Shelf clock. Ca. 1808-1835. Courtesy Smithsonian Institution. This clock, made by Riley Whiting in Winchester, Connecticut, has wooden works and is weight-driven.

The American Image

The American image is a compound of heroes and symbols, of signs and emblems. The cherished ideals incorporated in the Declaration of Independence can be suggested and summarized by a glimpse of the flag; a portrayal of the face of George Washington can represent the struggle to attain nationhood. Every day we confront patriotic motifs in paintings, in cartoons, on posters. Although we usually grant them little more than a momentary recognition, their power to inspire devotion cuts across all boundaries of intellect and sophistication. In times of historic celebration—or in periods of stress or danger—an image of our nationhood may evoke a powerful emotional response. We learn of martyrs who have faced terrible persecutions carrying emblems of their religious belief. We read in our first history books of impassioned patriots who have sacrificed their lives on battlefields in defense of a scrap of cloth—the symbol of their most cherished principles and their total allegiance.

From the early days of colonization the adventurous people who settled on our shores looked for symbols to represent the new land. Colonial seals and colonial flags incorporated a wide range of allegorical human and animal figures as well as native trees and crops. The evergreen New England pine tree appeared on the 1652 shilling, minted in Boston, and later on flags of the Revolutionary period. A confusing array of symbols and designs appeared on militia pennants and on banners flown by American ships. The only universally recognized symbol of the North American continent was one used in Europe: a powerful bare-breasted Indian woman wearing a feathered headdress and skirt, armed with lethal primitive weapons.

With independence the formal search for an official family of symbols began. In 1777 the flag of thirteen stripes and thirteen stars was adopted by the Continental Congress. The design of the bald eagle for the Great Seal was made official in 1782 after six years of debate. The dusky female Indian evolved into a neoclassical Goddess of Liberty, who carried olive

wreaths along with her sword and shield. The masculine figure representing our nation, Uncle Sam, was the last major symbol to make a debut, having superseded a pair of New England bumpkins named Yankee Doodle and Brother Jonathan who never developed sufficient class to qualify. Greatly beloved presidents have become patriotic folk heroes and, in the case of George Washington in particular, have been used as symbols for the nation.

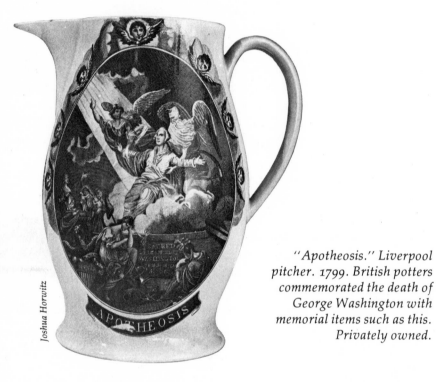

Joshua Horwitz

"Apotheosis." Liverpool pitcher. 1799. British potters commemorated the death of George Washington with memorial items such as this. Privately owned.

After the Revolutionary War the former colonists found themselves citizens of a new nation—members of an independent pioneering society guided by lofty democratic ideals, free from the tyranny of the tradition-bound monarchies of Europe. The triumphant Americans enjoyed an intensity of national pride that can scarcely be imagined today. It was an innocent pride, charged by an exhilarating sense of adventure—boundlessly optimistic, ebullient, fearless. Until the sobering tragedy of the Civil War most Americans felt fully confident that the combined forces of liberty, equality, and freedom could subdue any external assault and dispel whatever internal dissensions might arise.

Americans of all degrees of education, sophistication, and wealth loved their land with a total lack of restraint. They were insatiable in their desire to praise the country and to hear it praised in ringing oratory. They venerated the symbols of their nationhood and wanted to display them—all of them—everywhere, always. For, after all, a symbol can only be fully enjoyed when it's seen close at hand every day, hanging over the door, over the mantel, on a pole; woven into the coverlet, painted on the tea set, inlaid on the cupboard. The new patriotic iconography inspired artists, folk artists, and craftsmen alike.

In the eighteenth and nineteenth centuries professionally trained painters and sculptors were the only people ever described as artists. Today the self-taught painters and whittlers who fashioned wood carvings, pictures, and pictorial needlework as a means of creative expression are referred to as "folk artists," a term which did not originate until the 1930s and '40s when American folk art began receiving the respectful attention of collectors, museum officials, and critics. Most twentieth-century folk artists are amateurs, who work only for pleasure or to express compelling visions. In earlier times a great many self-taught painters known as limners traveled from town to town making portraits and signs and painting decorations on walls and over mantels for pay or for barter. In contrast to folk art, in which each piece is a unique work, the term "popular art" is generally used to describe work intended for mass viewing or mass consumption which may be mass-produced, either by hand or by machine—steel engravings, coins, stamps, carved furniture, mirror frames, clock cabinets, trade signs, figureheads, carousel and circus wagon carvings, crockery, glassware. Although definitions vary, the designation "decorative art" refers to the popular art of craftsmen who make items used in the home.

In our early crafts society, when virtually every decorative or useful item was made by hand, sign painters and carvers, carpenters, weavers, tinsmiths, and potters fervently set out to depict the eagle, the flag, the Liberty figure in all shapes and sizes. One form of art influenced another. Academic artists painted portraits of the first president and the founding fathers which were destined to be seen by only a limited number of elite viewers. Yet as soon as these official portraits were completed, engravers copied them and made large editions of prints to distribute to the general population. Self-taught amateur folk carvers and painters, inspired by depictions of patriotic symbols and heroes in popular prints, on coins, on inn and tavern signs, on broadsides and documents, were propelled by straight-from-the-heart patriotism to

11

carve their own eagle, paint their own Miss Liberty, try whittling a figure of George Washington on horseback. Skillful self-taught itinerant painters satisfied prevailing taste by painting eagles, flags, and images of Washington and the allegorical Miss Liberty on signs or on parlor walls. Young women who attended academies painted eagles on velvet; educated young men who studied calligraphic drawing favored patriotic subjects.

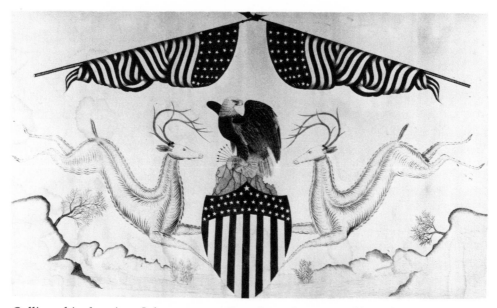

Calligraphic drawing. Ink on paper. Ca. 1877. Courtesy Abby Aldrich Rockefeller Folk Art Collection, Williamsburg, Va. The art of calligraphy, to which this sort of drawing is closely allied, reached its peak about the time of the U.S. Centennial, when patriotic symbols were particularly popular in all the arts.

The sight of a flag waving colorfully from a pole topped by an eagle inspired craftsmen to paint flags on chests and crocks and to carve and inlay eagles on chairs and mirror frames. Proud housewives hooked rugs, sewed quilts, made needlepoint pictures, and wove coverlets, incorporating eagles and flags and perhaps even a word or a motto. LIBERTY, INDEPENDENCE, and E PLURIBUS UNUM were inscribed on bedcoverings, on crockery, on the eagle and shield carving over the door. Farmers favored patriotic motifs for their gates, their weathervanes, and their whirligigs. Early settlers in Pennsylvania brought a traditional folk art from Germany, and soon their illuminated documents—known as

fracturs—included depictions of the eagle, American flags appeared on their painted linen chests, and George Washington became a subject for their carved and cast plaster sculpture.

The interest in patriotic artifacts zoomed to its greatest heights during and immediately after periods of national crisis. After the War of 1812—when the strength of the new nation was tried and reestablished—patriotic motifs were incorporated into every object of decorative art used in the home. Fashionable taste—as well as the untutored enthusiasm of humble citizens—favored excess. It was commonly agreed that there simply could not be too many images of George Washington, more than enough eagles, too great a clutter of flags.

From the time of the Revolution and on through the first half of the nineteenth century many of the wares decorated with American patriotic motifs were made in Europe and in the Orient, specifically for export. European etchings showed Washington and Franklin and Jefferson. Oriental painters and stitchery experts turned out reverse paintings on glass of American heroes and elegant silk embroidered pictures of the eagle and shield. English printed fabrics were decorated with American themes.

Almost all the porcelain and pottery dinnerware used in this country came by the shipload from England and China until late in the nineteenth century. Many affluent citizens disposed of their wooden and pewter dishes soon after the Revolution and designed their own dinnerware—often featuring eagle and flag designs—which was then made to order in the Orient. George Washington owned several such sets.

The British potters were particularly aggressive in wooing the American trade. Before and again after the Revolutionary War the Liverpool potteries turned out quantities of transfer-printed jugs with illustrations and mottoes praising and glorifying the struggle and then the victory of the colonists over Britain. Portraits of Washington (sometimes shown with a foot on the British lion), Franklin, Jefferson, and other American patriots appeared over and over again. Frankly treasonous mottoes such as SUCCESS TO AMERICA were commonly used on mugs, pitchers, jugs, and punchbowls. After Washington's death several popular Liverpool pitcher designs depicted his grave and his ascension to heaven. Politics was politics, in the minds of the potters of England—and business was business.

At the end of the War of 1812 best-selling British mugs and plates showed American naval heroes and their ships. Blue and white Staffordshire plates were indiscriminately decorated with scenes of the new

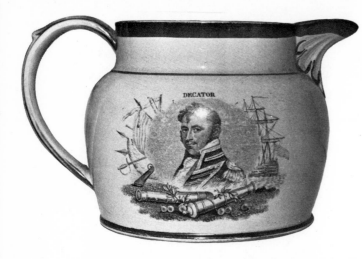

*English pitcher. Ca. 1816.
Courtesy Smithsonian Insti-
tution. British potters made
great numbers of mugs,
jugs, plates, and pitchers
commemorating American
naval heroes of the War of
1812. Note misspelling of
Stephen Decatur's name.*

country—the Boston State House, Niagara Falls, prisons, and ware-
houses. When the aging General Lafayette returned to visit the United
States in 1824 as a guest of the nation great quantities of cheap souvenir
dishes and mugs—most of them made in England—were snapped up by
enthusiastic Americans.

All forms of American popular art continued to satisfy prevailing
taste by adopting patriotic motifs. Ship carvers, who learned their craft
as apprentices in seaport towns, were taught to fashion eagles in the
round or in relief to decorate the bows, sterns, and galley boards of
wooden sailing vessels. Storage crocks made of stoneware bore eagle
and flag designs. Volunteer fire companies dubbed themselves "Li-
berty" or "Independence" or "Eagle" and adopted appropriate symbols
for their helmets, their fire buckets, the painted panels on the pumpers.
Prints of battle scenes from the Revolutionary War and the War of 1812
were displayed in inns, public buildings, private homes. Eagles, flags,
and the figure of Miss Liberty appeared on wooden weathervanes
carved at home and iron vanes cast in factories. Political candidates were
portrayed on porcelain and glass plates which were exhibited on shelves
and in cupboards and carefully copied by amateur painters. When the
new art of photography brought images of presidents and military
heroes to people all over the country—this new source inspired folk
artists to pick up their paintbrushes, their whittling knives, their tapes-
try needles.

In the late nineteenth century patriotic symbols also began to appear
in advertising art. It was only a very brief step from recognition of the
fact that Americans yearned to buy representations of our national sym-
bols to the dawning comprehension that depictions of these figures
could be used to sell *other* products and services. The relationship be-

14

tween Miss Liberty and tobacco, between the eagle and canned milk, between Uncle Sam and kitchen stoves might not be apparent at first, but it had already become obvious that the patriotic image sells. The extraordinary number of "Eagle" inns and "Washington" taverns and hotels in the preindustrial era is probably evidence of the owners' heartfelt patriotic enthusiasm combined with a savvy business instinct.

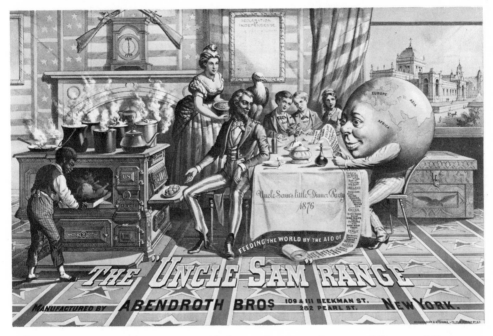

"The 'Uncle Sam' Range." Colored lithograph. 1876. Courtesy Library of Congress. In 1876 Uncle Sam advertised kitchen ranges (and many other things); in 1976 he advertised kosher frankfurters on television (and many other things).

The exploitation of patriotic symbols in the advertising of commercial products began in the early years of industrial growth and became fullfledged in the latter part of the nineteenth century, when—due to developments in color lithography—the poster blossomed both as an art form and as an advertising medium. Suddenly it was possible not only to dub a product "Eagle" or "Liberty" but to display, in an ad or on a label, a striking full-color image of the beloved symbol endorsing the product.

A vividly colored turn of the century cigar box label features an unusual Liberty figure, still dressed in the liberty cap and Grecian sandals of the traditional Miss Liberty, carrying Miss Liberty's shield and

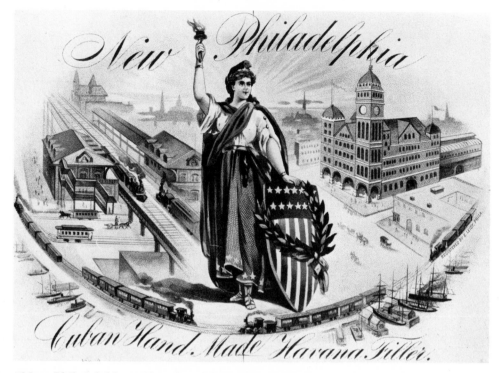

"New Philadelphia." Cigar box label. Chromolithograph. Philadelphia Museum of Art: Given Anonymously. The illustration obviously postdates the installation of the Statue of Liberty. Note newfangled torch held by Liberty figure.

laurel wreath, but holding aloft in her other hand the torch of the new image—that of the Statue of Liberty in New York Harbor. Other tobacco manufacturers dropped the Grecian goddess completely in favor of the trendier crowned figure from France. In 1975 Liggett & Myers, the tobacco company, kept up the tradition of associating smoking with our hallowed concepts of Liberty.

While Miss Liberty was busily pushing the all-American crop, so was Uncle Sam. Although rarely seen smoking or chewing in cartoons, the stern old uncle was used freely by retailers as a tobacconist's trade sign (see page 96) and, given a jolly smile, was shown in posters hawking numerous tobacco products. Uncle Sam and Miss Liberty have also appeared in ads for kitchen ranges, sewing thread, paint, pens, toys, and a host of other common manufactured items. The eagle, sometimes accompanied by the flag, has spread his wings on numberless newspaper and magazine mastheads, on an immense variety of canned and boxed foods

16

Advertisement for L&M cigarettes. Liggett & Myers, Inc. 1975.

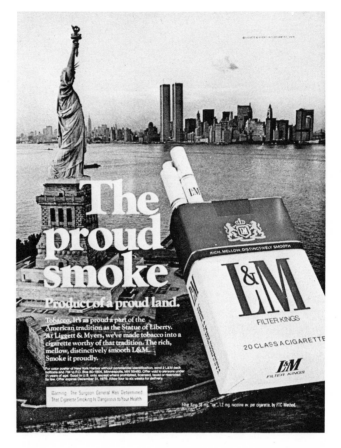

"America-Taffeta." Fabric ad featuring eagle and shield. Courtesy Smithsonian Institution.

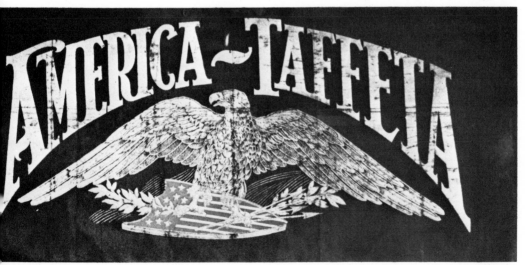

Elinor Horwitz

and manufactured goods. Athletic teams of every type have adopted the name and the image of the national bird. The number of products that have been sold in this country because the label or the advertisement included a picture of the flag—or simply the colors red, white, and blue—has never been counted. Nineteenth-century whiskey and bitters flasks were commonly embossed with eagles and with portraits of presidents, soldiers, and statesmen. Although the careworn face of Abraham Lincoln must have seemed too somber to use on an ad, George Washington appeared on cigar box labels and on this boldly colored 1910 broadside for a cereal enterprisingly dubbed "Washington Crisps." This odd and inglorious image of the Father of Our Country shows the familiar face perked up and dandified by a goodly application of rouge.

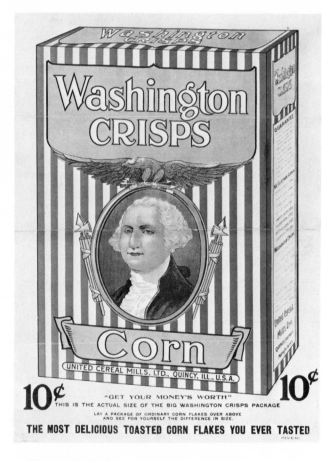

"Washington Crisps." Ad from United Cereal Mills, Ltd. Colored lithograph broadside. 1910. Courtesy Metropolitan Museum of Art: Jefferson R. Burdick Collection.

The colorful circus posters, theater posters, and political posters which burst upon an appreciative public at the end of the nineteenth century became increasingly popular in the twentieth. Some of the best-de-

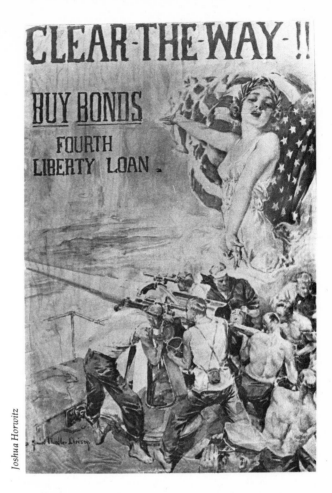

"Clear-the-way-!!" Fourth Liberty Loan Campaign. World War I poster. Collection of Anthony Horwitz. Howard Chandler Christy, popular portrait painter and illustrator, decked his famous "Christy girl" in Miss Liberty's Grecian gauze in this seductive bond appeal poster. The remote and modest Goddess of Liberty became a glamor girl.

Joshua Horwitz

signed work in this medium appeared during World War I. Our entire family of symbols was called to duty in the cause of recruitment, war loan campaigns, and special government projects allied with the emergency. Bringing about the acceptance of national policies and programs called for a more skillful and extensive effort than the promotion of a new brand of lead pencil or chewing tobacco. Leading artists of the day were hired to paint striking posters that would unfailingly attract the eye and convey the message. The best-known war poster of them all is James Montgomery Flagg's Uncle Sam (page 103), who points a firm index finger and says I WANT YOU FOR U.S. ARMY. The poster sold more than 4 million copies during World War I and almost half a million during World War II.

At times of national commemoration folk and popular art based on patriotic imagery appears in great quantity—some of it folk art of considerable charm inspired by heartfelt patriotism, and a good bit of it tasteless kitsch manufactured in a totally unharnessed commercial spirit.

America's centennial bash took place in Philadelphia in 1876. For ten

19

months the one hundredth anniversary of the Declaration of Independence was celebrated as a grand exposition of developments in manufacturing and the arts. Souvenirs of the fair sold in great quantity. They are avidly collected today, although a hundred years ago many of these items seemed as tasteless as 1976's red, white, and blue toilet seats. Inexpensive glassware showing the Liberty Bell was in great demand. Other popular glass mementos included a coin bank shaped like Independence Hall, an American flag platter, renditions in glass of the Declaration of Independence and of Betsy Ross making a flag. The first needlework kits—using the Liberty Bell symbol—were sold. The most talked about art object at the Exposition was the hammered copper arm and

Liberty Bell sampler. Silk on paper. Courtesy Philadelphia Museum of Art: The Whitman Sampler Collection: Given by Pet Incorporated. This stamped and perforated pattern, an early do-it-yourself kit, was sold at the national Centennial Exposition in Philadelphia.

Arm and torch of the Statue of Liberty. From Frank Leslie's Historical Register of the Centennial Exposition. 1876. Courtesy Philadelphia Museum of Art. Visitors at the exhibit could climb a stairway and step out on the platform surrounding the torch to view the fairgrounds. In 1886 the entire statue was erected on Bedloe's Island in New York Harbor.

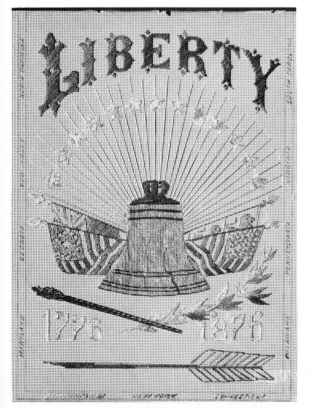

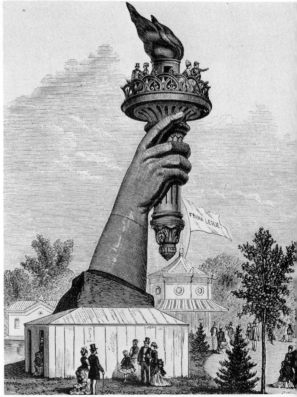

torch of the Statue of Liberty. The statue itself—designed as a centennial gift from France—was not to be completed for several years, but awed fairgoers climbed up into the arm and the torch to view Philadelphia, and were overwhelmed by the experience. This handsome quilt is a folk art reminder of the centennial—ingeniously designed with mass-produced George and Martha handkerchiefs sewn onto an entirely hand-blocked, hand-sewn flag design in chintz.

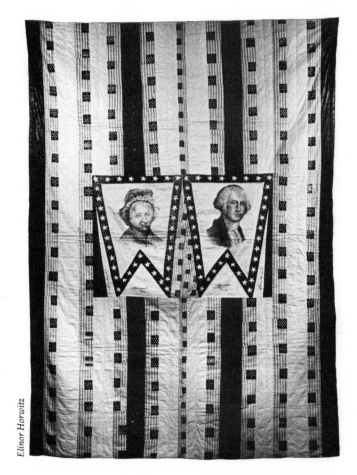

Centennial quilt. 1876. Courtesy American Folk Art Shop, Washington, D.C. Hand-blocked and hand-sewn, incorporating hand-kerchiefs with portraits of the Washingtons.

Elinor Horwitz

In 1892 the World's Columbian Exposition celebrated the four hundredth anniversary of Columbus's discovery of America. It brought forth a number of "portraits" of the fifteenth-century explorer. Not a single picture of Columbus was made during his lifetime, but this in no way troubled the manufacturers of souvenir plates, paperweights, goblets, and perfume bottles, who unhesitatingly rendered his image on

Columbus's Landing. Collage made of cut-up Columbian Exposition postage stamps. 1892. Collection of Herbert W. Hemphill, Jr.

china or glass. This collagelike picture of the landing of the three Spanish ships in North America was made in 1892, entirely of Columbian Exposition commemorative stamps.

In 1932 the two hundredth anniversary of George Washington's birth brought forth another spate of plates and cups and goblets. Reproductions of the painting of Washington in his Masonic apron—made for the event—now hang in every Masonic Lodge in the United States that was chartered before 1932. The original—which is displayed in the Alexandria, Virginia, George Washington Masonic Temple—is actually a portrait of an actor named Tefft Johnson, who often portrayed Washington on the stage and who was asked to pose. Johnson wore the ceremonial Masonic apron and jewel owned by Washington, who, like many prominent Americans of the period, was a devoted Freemason. The Washington Bicentennial Commission had ten thousand copies of the portrait made to use in promotion.

During 1976, "bicentennial" soap, pens, ice buckets, platters, alarm clocks, cologne, playing cards, knee socks, sneakers, shower heads, and

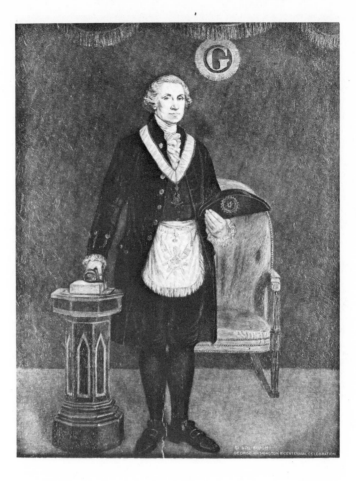

George Washington in Masonic apron. Hattie E. Burdette. 1932. Courtesy George Washington Masonic National Memorial Association. This portrait was made for the bicentennial of Washington's birth.

a host of other products appeared—items which owed more to marketing ingenuity than to artistic good taste. But the occasion of the national bicentennial inspired any number of odd, amusing, and interesting phenomena in addition to the gimcrack souvenirs. Many cities painted their buses red, white, and blue, and in downtown Atlanta the hydrants were decorated in the national color scheme. Braniff International commissioned artist Alexander Calder to paint their flagship red, white, and blue (page 65).

In Washington, Virginia, a county seat town in the foothills of the Blue Ridge Mountains, a special pride was felt. Of the twenty-eight Washingtons in the country, historians of Washington, Virginia (pop. 185), feel that theirs was first—and, furthermore, that it was surveyed and platted by seventeen-year-old George Washington in 1749. When each county in the state was asked to design a needlepoint square for a large state tapestry, the women of the local County Extension Homemakers Club made an obvious choice. Their square (page 65) shows the ubiquitous local apple orchards, the gently peaked mountains, the

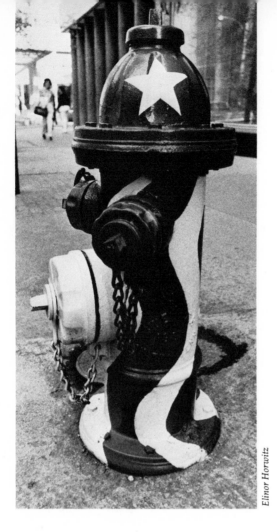

*Fire hydrant painted
red, white, and blue.
Atlanta, Georgia. 1976.*

Elinor Horwitz

town's historic tollhouse, and our first president making his survey.

In the Publick House Restaurant in Sturbridge, Massachusetts, near the famous colonial restoration, chef Albert Cournoyer and assistant Michael Poirier honored the bicentennial by making a 5½-foot-high tallow sculpture of the Colonial Minuteman. Another extraordinary construction inspired by our two hundredth birthday was Kansan Mitsugi Ohno's glass rod model of the Capitol building (page 31).

Speculation about the future uses of patriotic imagery can only be optimistic. The purely exploitive adaptations of the traditional symbols—such as a Liberty-Bell-shaped brandy decanter that plays ''The Star-Spangled Banner'' when you tip it to pour—are certain to decline due to postbicentennial fatigue. But the folk artists of our time, who, like folk artists of the past, create paintings and carvings simply as an expression of personal devotion, will continue to derive inspiration from the emotionally charged and—to the creative spirit—forever suggestive symbols of our nationhood.

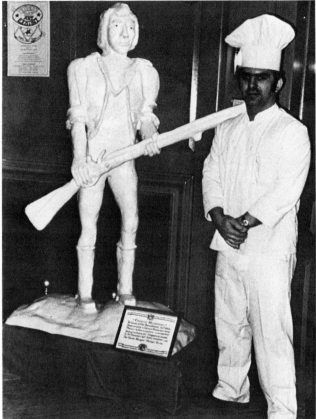

Colonial Minuteman. This 5-foot 6-inch tallow sculpture was made for the Publick House Restaurant in Sturbridge, Massachusetts, by executive chef Albert Cournoyer and assistant Michael Poirier. This type of work is a recognized form of culinary art. The figure was made to honor the bicentennial and decorated the foyer of the restaurant.

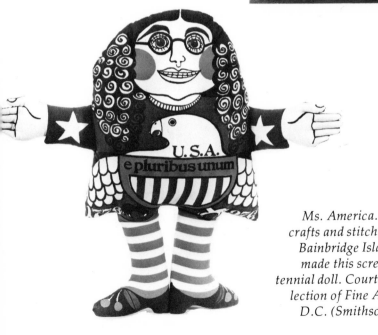

Ms. America. Susan Adamson, crafts and stitchery designer from Bainbridge Island, Washington, made this screen-printed bicentennial doll. Courtesy National Collection of Fine Arts, Washington, D.C. (Smithsonian Institution).

Symbols

Symbols are a form of shorthand, which we learn to read in our earliest years. We discover as very young children that we can identify the enemy by the emblem—that no school, camp, or professional athletic team could possibly compete without displaying a symbolic animal, a pennant, or simply a particular color. Otherwise, how would the fans know when to cheer and when to boo? Every day we see any number of familiar symbols—an American flag, caricatures of Uncle Sam, the Republican elephant and the Democratic donkey, an eagle on the masthead of a newspaper, the peace sign, a crucifix or Star of David, the logos of manufacturers or of television networks. Many of us habitually wear symbolic objects on our persons—wedding rings, religious medals, military decorations, fraternity or scout pins, Phi Beta Kappa keys. Other people, noting these insignia, learn something about us, and their response to us may be colored by their personal associations with the symbols of identity and allegiance we display.

Patriotic symbols are part of our history, our cultural heritage, our everyday experience. Over the two hundred years of our nationhood, the major symbols have been the flag, the eagle of the Great Seal, Miss Liberty, and Uncle Sam. But a great number of other images have been used through the centuries, and most of them are still recognized today.

The rattlesnake is a fearsome creature. To the pioneering Americans of the eighteenth century he was a fascinating reptile, unknown in Europe. Because he had no eyelids he was considered a symbol of vigilance. And because he never attacks without provocation—and never surrenders to an assailant, once provoked—he became a powerful symbol of the rebellious colonists. The motto DON'T TREAD ON ME, which appears on flags of the Revolutionary War period picturing the rattlesnake, meant just that: Don't press too hard because I'll attack—and my bite is deadly.

The pine tree is green all year and has therefore been used as a symbol of life. In the Massachusetts colony, it was the prevailing symbol on

26

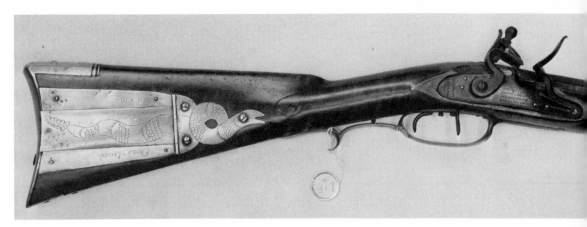

Rattlesnake on patchbox. Rifle made by William Weiss. Courtesy George Shumway, publisher. The symbol of the rattlesnake and the motto "Don't Tread on Me" decorate the brass patchbox of this American longrifle probably made in Lancaster, Pennsylvania, in 1807 or 1808.

coins and flags. Another specimen—shown as a tall, spreading shade tree—was also used symbolically and was called the Liberty Tree. The Sons of Liberty were members of a secret patriotic society which was begun before the Revolutionary War. Trees under which they gathered—and where they hanged British officials in effigy to protest the Stamp Act—later became known as Liberty Trees. Such trees appear in many early drawings and on printed fabrics and seals as symbols of the new land. A Liberty Tree also appears on a 1976 thirteen-cent stamped envelope.

Liberty poles—long poles which were symbols of the same trees—were erected in town squares. They were often topped by liberty caps and are shown held by Miss Liberty in numberless paintings and carvings and on seals and coins. When Miss Liberty isn't toting the cap on the top of a pole she is frequently wearing it on her head. The droopy "stocking cap" as a symbol of liberty derives from classical times, when hats of this type were worn by liberated slaves to show they had been freed. Even earlier the Phrygians of Asia Minor used similar caps to distinguish free citizens from slaves. As early as the third century B.C. the cap was often carried aloft on the top of spears in festivals. The symbolic cap was used during the French Revolution with the same connotation of freedom from slavery. Carved wooden liberty caps were mounted on wooden poles and carried in American patriotic parades or at political campaign events.

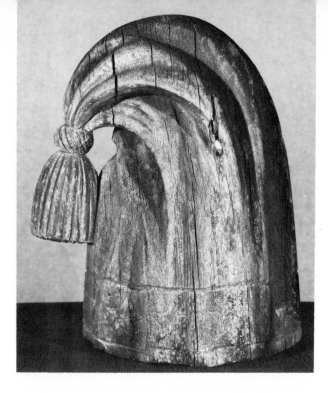

Liberty cap. Painted wood. Ca. 1800–1825. Reproduced through the courtesy of the New York State Historical Association, Cooperstown. Caps like this one were carried on the tops of poles in patriotic parades.

Although a female Indian appeared in European publications as a symbol of the North American continent, colonists used the figure of an Indian brave on early seals. Later, when Indians were no longer seen as a threat to the people of the eastern states, they became the most popular subject for trade figures. Carved and painted Indian braves and maidens stood outside virtually every tobacconist's shop during the late nineteenth and early twentieth century. Shown with drawn bow, the Indian was a popular figure on beaten copper weathervanes during the last quarter of the nineteenth century.

After the death of George Washington, so many paintings of Mt. Vernon were made that the first president's home became an emotionally imbued symbolic patriotic scene. The natural phenomenon known as Niagara Falls—a place considered sacred by a number of eastern Indian tribes—attained the same sort of symbolic standing.

Independence Hall and the Liberty Bell have been represented, as images of America, on paintings, in glass, in needlework, on quilts and coverlets. Manufacturers of inexpensive souvenirs turned out postcards, statuettes, and glassware featuring the building and/or the bell for the nation's Centennial Exposition. The Capitol building was also a popular symbol in 1876. The coverlet on page 30, which was made during centennial year, shows the new wings and dome which had been completed only a decade earlier.

The Liberty Bell and the Capitol Dome were spectacularly reproduced

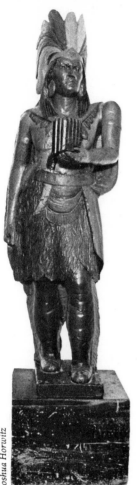

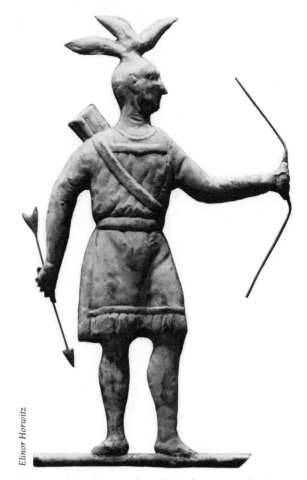

Joshua Horwitz

Elinor Horwitz

Tobacconist's figure.
Wood.
Late nineteenth century.
Privately owned.

Massasoit Indian archer. Weathervane. Copper.
Second half of the nineteenth century. Courtesy
Heritage Plantation, Sandwich, Mass. This In-
dian is similar to the one on the Massachusetts
state seal.

on the grounds of the Centennial Exposition. The bell was rendered in sugar, in chocolate—and full-size in soap. The dome was featured in an exhibit from the state of Kansas, described in the Parsons, Kansas, *Sun* as "The most beautiful and novel ornament in the Exhibition." Placed beneath a replica of the bell, the twenty-foot-tall model of the Capitol dome

> was covered with winter apples of various hues and was
> supported upon a series of glass columns, filled with barley,
> oats, corn and other cereals giving them a checkered and

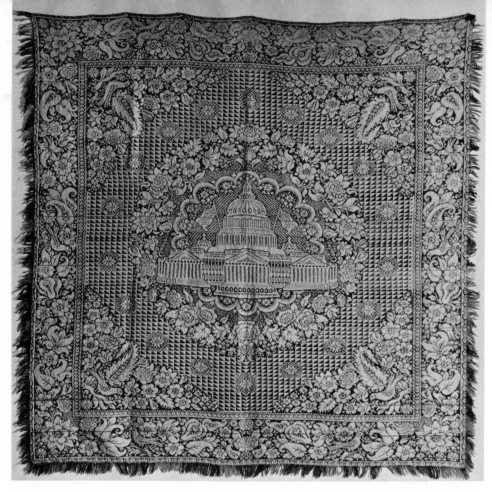

Woven coverlet. Wool and cotton. 1876. Courtesy Smithsonian Institution. This seamless jacquard double-woven coverlet with central medallion of the Capitol is in shades of red, green, purple, brown, and white.

Model of Liberty Bell and Capitol dome. The dome is constructed entirely of produce grown in Kansas and was made for display at the Centennial Exposition in Philadelphia.

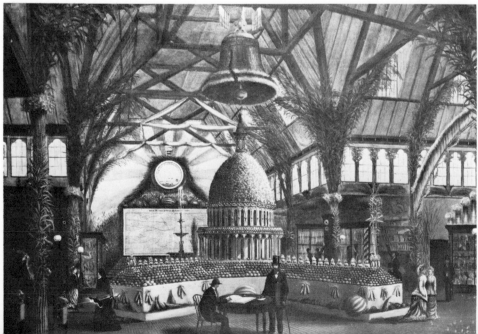

pleasing appearance. These, in turn, rested upon a cruciform table, which was literally filled to overflowing with specimens of apples, pears and grains; and at the foot of the latter was a narrow platform filled with vegetables of such gigantic growth as is only known in the west; among them being superb sweet potatoes, colossal ears of corn, beautiful beets, ponderous onions and weighty squashes.

It must have been a mouth-watering sight.

During bicentennial year another spectacular and bizarre model of the Capitol attracted considerable attention. Mitsugi Ohno, a native of Tokyo, came to America in 1962 to work as a scientific glassblower. He has made an outstanding reputation for himself transforming glass tubing into complicated items of scientific equipment for researchers at the physics department of Kansas State University. As a hobby, Ohno makes models out of glass. Because of his deep affection for his adopted land, he has been particularly interested in American landmarks. His model of Independence Hall was presented as a gift to President Nixon in the early 1970s. This scale model of the Capitol, which was presented to the Smithsonian Institution in Washington, D.C., as a bicentennial gift, took four years of his spare time to make and was by far his most ambitious work.

Mitsugi Ohno shows his glass rod model of the U.S. Capitol to Kansas Congresswoman Martha Keys.

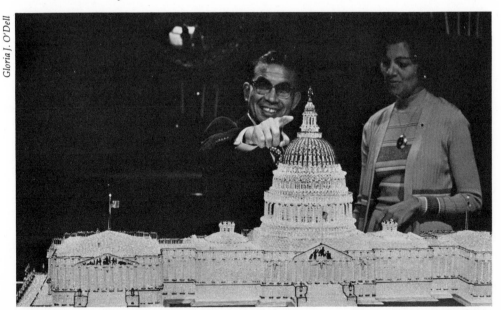

A map of the United States can be readily accepted as a patriotic image. Mary Borkowski of Dayton, Ohio, has been making extraordinarily beautiful quilts based on patriotic themes for several decades. The My America quilt was started in the late 1950s, but she has added to it as historic events occurred. Blue dots on the map mark the locations of state capitals. A red star marks Washington, D.C. Thirteen red roses form a circle at the top of the quilt and within the circle are white quilting stitch silhouettes of Robert Kennedy and Martin Luther King—added since this photograph was taken. Thirteen blue stars surround the Great Seal. In the corners of the border, which is decorated with broken hearts, are portraits of the four assassinated presidents.

"My America" quilt. Appliquéd, quilted, and embroidered. Mary Borkowski. Privately owned. Ms. Borkowski started this quilt in the 1950s. Notice four assassinated presidents in corners of border.

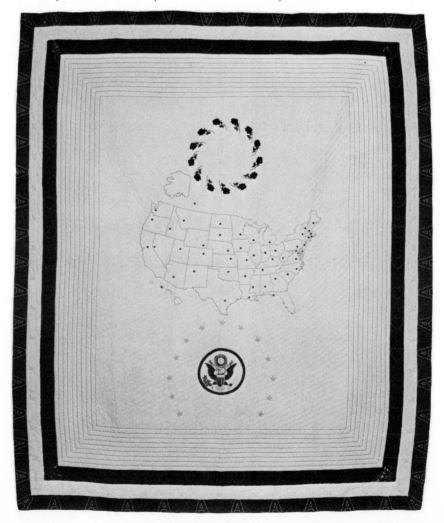

Slogans have served to stir patriotic sentiments at all times. LIBERTY OR DEATH, E PLURIBUS UNUM, DON'T TREAD ON ME, or simply the word UNION appeared on crockery, on printed fabrics, on all types of decorative items used in the home during the late eighteenth century and all of the nineteenth. This World War II tattoo flash exhibited in tattoo parlors inspired countless servicemen to display their patriotic fervor in perpetuity on their chests or on their arms.

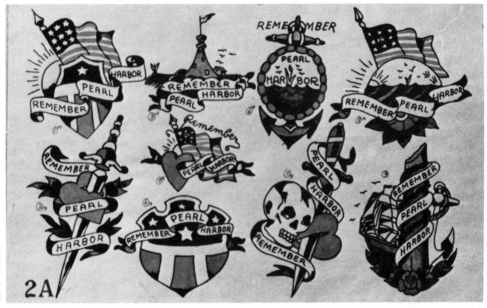

Tattoo flash. Collection of Herbert W. Hemphill, Jr. Customers view these paintings and select the designs for their tattoos.

Perhaps the best-known patriotic symbol of World War II was the V for Victory sign, which originated with a hand signal used by Winston Churchill. Or did it? Actually, the use of the letter V as a symbol for victory dates from at least the late nineteenth century. The large wooden V on page 66, painted with stars and stripes, is thought to have been made and used in the late nineteenth or early twentieth century, probably for a campaign headquarters.

The V for Victory quilt on the next page was made by Mrs. W. B. Lathouse of Warren, Ohio. Notice the flags and symbols of the Allied nations, the Russian bear, English bulldog, and American eagle—who is busily tearing up Nazi and Japanese flags. The V is repeated in Morse

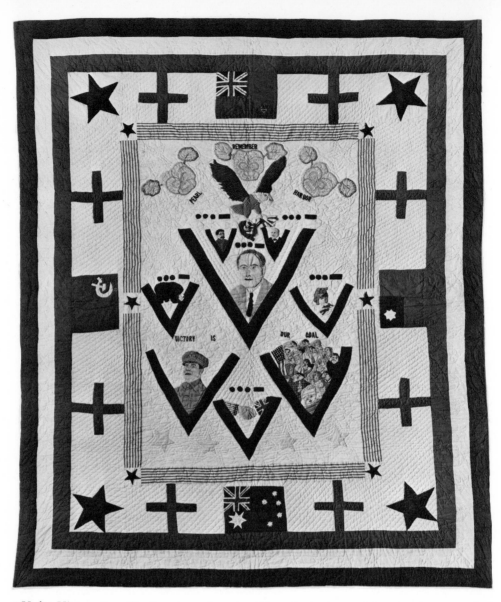

"V for Victory" quilt. Courtesy America Hurrah Antiques, New York, N.Y. This quilt was made during World War II by Mrs. W. B. Lathouse of Warren, Ohio. It includes nearly every patriotic symbol and hero of the time.

code above the symbolic animals and the portraits of Roosevelt, Church-ill, Stalin, and General MacArthur.

The four major symbols of our country—and their marvelously varied representations in folk and popular art—are examined in the following chapters. Long may they wave . . . fly . . . scream . . . point . . . reprimand . . . cajole . . . endure.

The Bald Eagle

Although most of us would find it difficult to identify a live eagle flying overhead, we immediately recognize virtually any representation of the celebrated bird as a symbol of the United States. Eagles appear on our currency, on the mastheads of newspapers and magazines, on posters, in advertisements, on the buttons of military uniforms and the shirts of postal workers. They are engraved on official documents of every sort; they hover over the entrances to United States embassies, consulates, and legations around the world; they decorate public buildings and monuments in cities across the country.

No patriotic symbol has been used so commonly as the bald eagle or in such a stunning profusion of forms. Ever since its official adoption as the symbol on the Great Seal of the United States the eagle has been an unrivaled favorite. Amateur and professional woodcarvers have portrayed the national bird in the round, in relief, in half-round and quarter-round; at rest, in flight, rising, alighting, attacking; with wings drooping, spread, folded. Craftsmen have used eagles as decorative devices atop mirrors, wall barometers, picture frames, flagpoles. Eagles have been painted or inlaid on highboys, lowboys, tables, blanket chests, chairs. Ship carvers made the eagle the dominant decorative device on wooden sailing vessels and riverboats. The eagle was stamped on medals and political campaign buttons, used on molded glass bottles, on snuffboxes, on metal buckles. As a printer's logo, the eagle has appeared on the front of numberless large and small newspapers in this century and the last. It has been used to suggest quality on the labels of patent medicines, canned foods, manufactured items of every sort. When our national aims and ideals are affronted the cartoonist's eagle screams; when the country faces internal problems the haughty bird has been known to weep.

The eagle became our official symbol (and forever after a source of artistic inspiration) on a specific date—June 20, 1782. The search for a suitably handsome and dignified design for the Great Seal of the United States had begun six years earlier, on July 14, 1776, when Congress appointed a formidably distinguished committee of three—Benjamin Franklin, John Adams, and Thomas Jefferson—to decide the matter.

Various suggestions were subsequently brought forth. One early idea

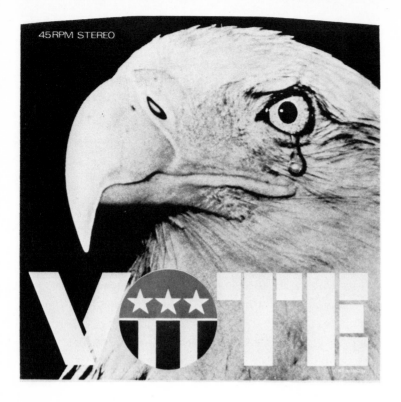

45 RPM STEREO

"Vote." Record cover. 1971. Courtesy Smithsonian Institution. Bob McQuade of McQ Inc. designed this weeping eagle as part of a campaign to increase registration when the eighteen-year-old vote was enacted. The eagle with a tear in its eye also appeared on posters, T-shirts, and buttons.

was that the seal show a shield with a Liberty figure on one side and a rifleman on the other. Both Franklin and Jefferson favored Old Testament scenes. Franklin proposed the figure of Moses dividing the Red Sea, complete with Pharaoh and his chariots being drowned in the tempest and the motto REBELLION TO TYRANTS IS OBEDIENCE TO GOD. Jefferson proposed a scene showing the children of Israel wandering in the wilderness, and on the reverse the Saxon chiefs Hengist and Horsa, from whom so many early settlers believed themselves to be descended. Adams, who had a particular fondness for the deities and legends of classical mythology, thought that the seal should depict a mountain-climbing scene in which Hercules would be shown ascending, guided by a maiden representing Virtue, while a seductive figure representing Sloth tried to pursuade him to lie with her at the base.

All three men finally concurred on an image of the Goddess of Liberty, with the shield of the states, accompanied by the Goddess of Justice, and the motto E PLURIBUS UNUM. The motto, which appears in the Latin poem "Moretum" by Virgil, was familiar to most literate Americans from a more popular source. It appeared on the title page of a popular London magazine widely enjoyed in this country, *The Gentleman's Journal*. It did not escape the notice of the founding fathers that the lofty Latin motto embodied an apt sentiment and that it also contained a symbolically appropriate number of letters.

The design was not a success with the members of Congress, and, with a sense of more urgent priority, the problem of the seal was dropped and the matter of adopting an official flag was taken up instead. In 1780 a new committee explored the subject of an official seal and proposed that the figure of a warrior holding a sword, accompanied by a maiden grasping an olive branch, might be an ennobling motif. The members of Congress thought it over—and turned it down.

A third committee, formed in 1782, enlisted the aid of a Philadelphian named William Barton, who was well versed in the subject of heraldry. His exuberantly cluttered design, which included an eagle, a harp, two fleurs-de-lis, a maiden representing Virtue, a dove, a shield, and a handsome soldier was submitted for editing to another Philadelphian, a classics scholar named Charles Thomson. Thomson's pared-down design, with some additional modification, became the official seal.

Not everyone who had been involved in the important decision favored the choice. Benjamin Franklin wrote a highly critical letter to his daughter Sarah Bache, saying:

> For my part I wish that the bald eagle had not been chosen
> as the representative of our country; he is a bird of bad

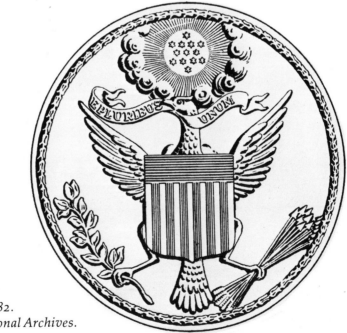

First die of the
Great Seal. 1782.
Courtesy National Archives.

moral character . . . like those among men who live by sharping and robbing, he is generally poor, and often very lousy . . . the turkey is a much more respectable bird, and withal a true original native of America.

The prudent Franklin also noted that the turkey, unlike the eagle, could be viewed as an economic asset because it was, after all, edible. Just try to eat an eagle!

The seal used today is the seventh die cut since 1782, and differs from the first in detail, if not in basic design. The crested head—not found on the American bald eagle—and the strange froglike legs and gawky long neck of the eagle on the first die have disappeared and been replaced by a more compact, anatomically realistic form. The current seal is seen in enlarged replica on the wall behind the president's chair when he speaks on television and can be examined on the back of the dollar bill. The bird is posed in what heraldry calls the "displayed" position, with wings and legs fully extended. An olive branch, with thirteen leaves and thirteen berries, symbol of peace, is held in the right talon, and a bundle of arrows is held in the left, symbol of war or of willingness to defend peaceful ideals. On the bird's breast is a shield with thirteen red and

Eagle headboard. Courtesy National Gallery of Art, Washington. Index of American Design.

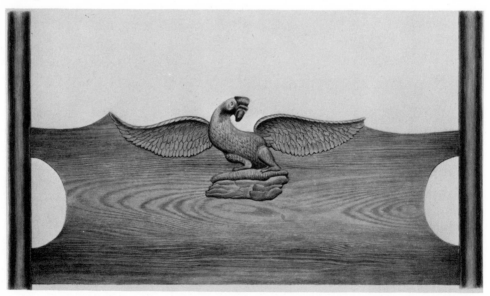

white stripes and thirteen stars. In his beak the bird holds a ribbon with the thirteen-letter motto E PLURIBUS UNUM. Above his head is a constellation composed of thirteen stars, surrounded by bright rays breaking through the clouds.

The eagle selected to represent the new land was not the European golden eagle, a bird which is found in many parts of the world, but the American bald eagle, which is found only on the North American continent. The bird is not bald in the current meaning of the word, but is distinctively white-headed with white feathers growing down its neck. The tail is also white and the legs are bare of feathers and yellow in color. The body feathers are blackish brown. Adult birds are 3 to 3½ feet high with a wingspread of 6 to 8 feet. They are indeed "eagle-eyed," having been known to spot prey from a distance of two miles, and they are capable of flying at speeds exceeding one hundred miles per hour.

The choice of the eagle as emblem of the new republic was certainly not in any sense original. Statesmen versed in history recognized the eagle as a time-honored symbol of independence, freedom, and strength. The eagle appears in the myths and religious beliefs of people of all lands and eras. Many ancient legends relate that the eagle, with his fierce gaze, is the only creature who can stare directly into the sun. American Indians considered the eagle sacred and prized its feathers. The eaglelike Thunderbird of Indian legends was considered to be the spirit of thunderstorms. To the ancient Greeks the bird also had meteorological associations as the messenger of Zeus, ruler of the elements. Romans linked the eagle with Jupiter, and legions in the field traditionally camped near eagles' aeries as a guarantee of military success. Like the earlier Sumerians, Assyrians, and Persians, Roman soldiers carried silver and gold figures of eagles as standards when they went into battle. Live eagles were also released over the ritual funeral pyres of Roman emperors to bear the dead men's souls to Olympus. To the Hebrews of the Old Testament the eagle symbolized the protection of the Lord.

As a symbol of statehood, the eagle has been used repeatedly. Charlemagne adopted the already traditional form of the double-headed eagle, which was later used by Ivan the Great to indicate that he had linked East and West by marrying the niece of the last emperor at Constantinople. The double-headed eagle also appeared on the coat of arms of the Austrian Empire. The Emperor Napoleon was so obsessed with eagles that his only son was known as "L'aiglon" (the eaglet). Each of Napoleon's regiments was led by a man carrying a standard topped with "Un

aigle éployé" (an eagle with wings outstretched). The standards were fiercely defended in battle and, when captured, were considered prize trophies. Napoleonic eagles seized at Waterloo or found on battlefields in later years still exist and can be seen displayed in European chapels and museums. In 1871 the Third Republic substituted the laurel wreath for the Napoleonic eagle. The Russian imperial eagle and the German eagle remained official national symbols until they were replaced in this century by the hammer and sickle and the swastika.

The eagle was an instant popular success, and despite its long history as a symbolic bird, possibilities for rendering and displaying the new national emblem seemed fresh, exciting, and limitless in variety. When George Washington made his triumphal tour of the thirteen states in 1789, citizens etched outlines of eagles on whitewashed front windows and placed lighted candles behind them to honor his appearance in their state. Ladies carried fans bearing painted or embroidered eagles and wore in their hair ribbons decorated with eagles. After the War of 1812 was won and the freedom and might of the new republic seemed thoroughly established, eagles appeared on dinner plates, on the stoneware crocks in the kitchen, on the fabric of the drapery and the napery. Wallpaper designs often featured eagles, and in humble cabins and comfortable middle-class homes women were inspired to hook rugs, weave coverlets, and design needlepoint pictures bearing the proud device of the spread eagle. Eagles were carved on butter molds, which were used to press designs into the pieces of butter cut from a block for the table.

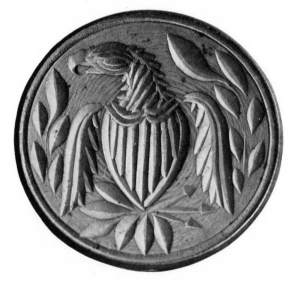

Butter mold with eagle design. Wood. Ca. 1875–1900. Reproduced through the courtesy of the New York State Historical Association, Cooperstown.

Appliquéd quilt. Hannah Childs. Ca. 1815. Courtesy DAR Museum, Washington, D.C.

They were embossed on iron stoves, carved and painted on all types of furniture. Eagle quilts were made throughout the nineteenth century and many fine examples survive today.

Although the eagle on the Great Seal remained the original source of inspiration, many liberties were taken with the form and posture of the bird. At times, particularly when it was being adapted to an architectural space, the design on the seal was stretched out horizontally, as in an early example carved by the celebrated architect and sculptor Samuel McIntire of Salem, Massachusetts. The eagle, which was made for the Salem Custom House, is now exhibited at Salem's Essex Insti-

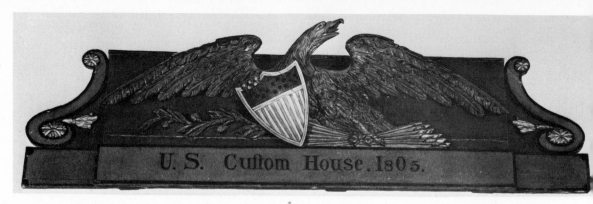

Carved sign for U.S. Custom House, Salem, Massachusetts. Samuel McIntire. 1805. Courtesy National Gallery of Art, Washington. Index of American Design.

tute. When the new custom house was built at Salem in 1828 Joseph True, a professional carver who had trained with McIntire, was hired to carve a grand new eagle to hover protectively at the edge of the roof. True's eagle, for which he was paid fifty dollars by the United States government, is one of the few architectural eagles from the early nineteenth century that are still in place on the buildings for which they were designed. Chronicler Nathaniel Hawthorne, who worked in the building as a customs collector while writing *The Scarlet Letter*, was less enthusiastic about the eagle than were others:

> With the customary infirmity of temper that characterizes this unhappy fowl, she appears, by the fierceness of her beak and eye, and the general truculency of her attitude, to threaten mischief to the inoffensive community.

During the long period of the wooden sailing vessel, ship carvers thrust the eagle forward as a figurehead and spread its wings widely in relief carvings for stern boards. John Haley Bellamy, the most famous eagle carver of the second half of the nineteenth century, fashioned an eagle with eighteen-foot wingspread for the bow of the U.S.S. *Lancaster*.

The carved wood eagle on page 44 and another like it were designed for the housing on the paddle wheels of a bark-rigged steamer, the U.S.S. *Michigan*. The *Michigan* was the first iron ship of the United States Navy, the result of a treaty which followed the War of 1812 permitting Canada and the United States each to build a five-hundred-ton armed ship to be piloted in the Great Lakes. Canada let the opportunity pass, but the United States built the *Michigan*. Despite great public skepticism about its buoyancy, the vessel, later renamed the U.S.S.

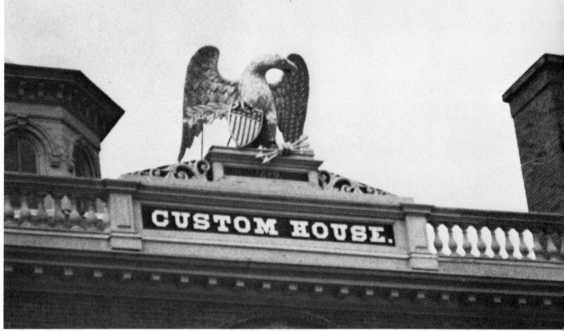

Carved eagle for "new" Salem Custom House. Joseph True. 1828. This is one of the few early architectural eagles still in place on the buildings for which they were made.

Flying eagle masthead for U.S.S. Lancaster. John Haley Bellamy. Courtesy National Gallery of Art, Washington. Index of American Design. This carved eagle has an eighteen-foot wingspread.

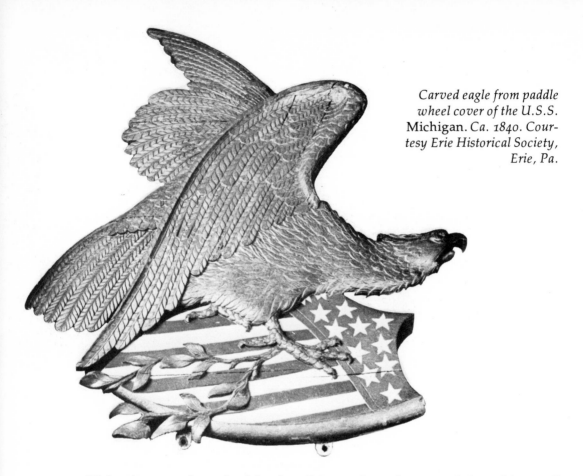

Wolverine, was launched in the 1840s and used as a training ship until 1924. She was still afloat on her one hundredth birthday in 1943 and was scrapped in 1949, after ramming and sinking her towing launch on the way to the wrecking yard. Her bow is still displayed at the foot of State Street in Erie, Pennsylvania.

Carvers varied the Great Seal's composition with enthusiasm, unhesitatingly replacing the eagle's arrows with lightning bolts, anchors, and other devices. They perched the bird atop the shield, an orb, or a cannon, or accompanied it with crossed flags or the old symbol of the rattlesnake. Painters popped it into pictures of George Washington or Miss Liberty. They removed the ribbon from its beak or replaced the hoary Latin motto with the designation of a military battalion, or a political slogan, or the name of a button factory, or the words VICTORY or TO THE POLLS, YE SONS OF FREEDOM, or—on the label of a bottle of Perry Davis's Vegetable Pain Killer—JOY TO THE WORLD. BEWARE OF COUNTERFEITS.

Many nineteenth-century eagle inn signs survive, as well as a number of contemporary descriptions. This one, made and used in Lexington, Massachusetts, shows an eagle who looks very like a turkey. Haw-

Flying eagle. 1800–1820. Courtesy Museum of Fine Arts, Boston: John Wheelock Eliot Fund. This eagle was displayed on the front of Samuel Williston's button factory in East Hampton, Massachusetts.

Inn sign. 1808. Courtesy National Gallery of Art, Washington. Index of American Design.

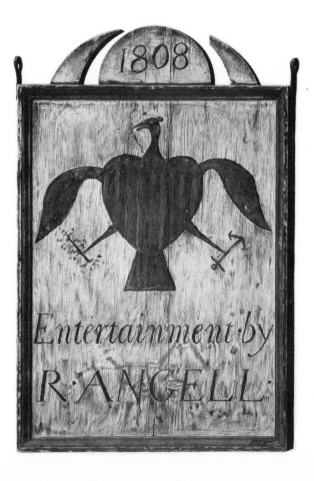

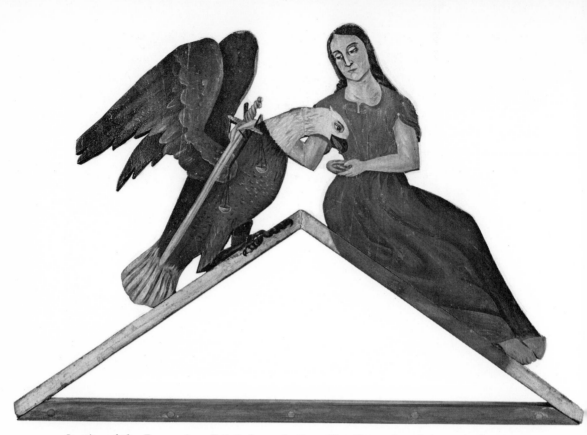

Justice of the Peace sign. Painted wood. Ca. 1880. Reproduced through the courtesy of the New York State Historical Association, Cooperstown. This sign was used over the office of a Justice of the Peace in Appleton, Ohio.

thorne's story "The Bald Eagle" concerns Lafayette's return visit to America in 1824, and takes place in a tavern in the Connecticut Valley:

> Before the door stood a tall yellow signpost, from which hung a white sign emblazoned with a fierce bald eagle, holding an olive branch in one claw, and a flash of forked lightning in the other. Underneath was written in large black letters, "The Bald Eagle: Good Entertainment for Man and Beast: by Jonathan Dewlap, Esq."

A quarter of a century later, in the 1850s, Edward Everett Hale traveled to Vermont and wrote home:

> Almost without exception their [the inn signs'] devices were of the American eagle with his wings spread or the American eagle holding the English lion in chains.

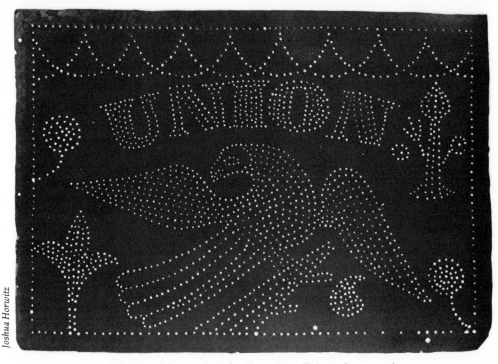

Tin panel from pie safe. Ca. 1860. Privately owned.

All nineteenth-century craftsmen learned to fashion eagles—the potter, the sign maker, the woodcarver, the painter, the weaver. Metalworkers made hammered copper eagle weathervanes and cast eagles in brass for buttons, buckles, and door knockers. Eagles were repeatedly depicted on coins and medals. Snow stoppers placed on sloping roofs were cast in the form of eagles. When tinsmiths fashioned perforated metal panels to ventilate wooden "pie safe" cupboards, used to store food, what could be more inspiring than punched-out pictures of the national bird? This one, made right after the Civil War, also bears a patriotic message—the one word UNION. Eagles were painted on fire engines and carved as sword handles. They decorated pressed glass plates and ornamented White House dinner services. Political campaign paraders carried poles topped with hollow metal eagles. The eagles were filled with oil and the torches were lit by means of wicks which protruded from the top.

During the Civil War eagles were painted on military drums with the banderole left blank for regimental name and number. In the field the

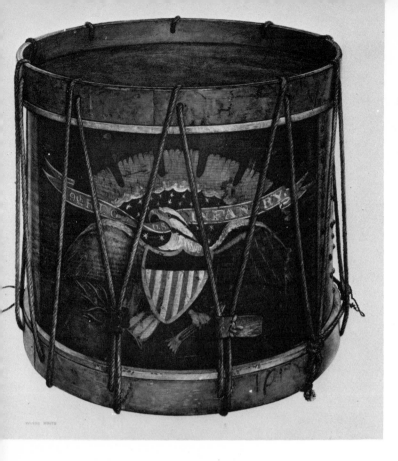

Civil War drum. Courtesy National Gallery of Art, Washington. Index of American Design.

drums were used—along with fife and bugle—to provide music and signal the orders to charge, retreat, or assemble.

Folk carvers—like everyone else—were exposed to the popular art of their era. They looked at the design of the gold "eagle" (ten-dollar) and "double-eagle" (twenty-dollar) coins; at the eagles on public buildings, on advertisements, on playing cards, election campaign banners, ballots, badges; on the sides of stagecoaches and fire engines and the mastheads of newspapers and made their own interpretations, inspired by straight-from-the-heart patriotic fervor. Homesick sailors, who went off to sea for several years at a time on whaling voyages, were often found carving or incising the shape of the eagle on small wooden boxes or on whalebone and whales' teeth during endless hours of enforced confinement.

Not all folk carvers drew their inspiration directly from the American prototype. Pennsylvania's most famous itinerant carver, Wilhelm Schimmel, carved eagles in the ruggedly decorative tradition of his homeland, the Black Forest area of Germany. Schimmel, who came to Pennsylvania after the Civil War, lived near the town of Carlisle in the Cumberland Mountains. Using a pocketknife, and a shard of glass for a smoothing implement, he carved boldly designed toys and animals and sold them

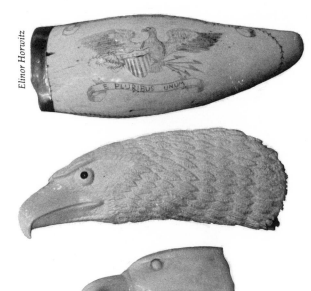

Scrimshaw eagles. Courtesy Heritage Plantation, Sandwich, Mass. Top: Incised whale tooth inscribed, "Tooth from a 109 bbl. Sperm Whale, May 9th, 1837." Center: Carved from a whale's tooth by Arthur Williams, an undertaker from New Bedford, Massachusetts. Ca. 1920. Bottom: Ca. 1840.

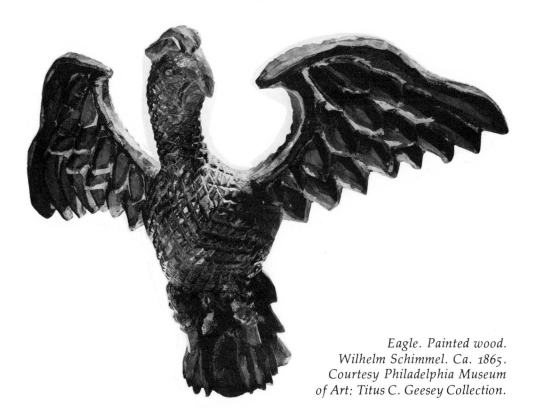

Eagle. Painted wood. Wilhelm Schimmel. Ca. 1865. Courtesy Philadelphia Museum of Art: Titus C. Geesey Collection.

for small sums or bartered them for food or drink. He died at seventy-three in the poorhouse. Today his eagle carvings are highly prized by museums and collectors.

This "Texas Eagle," carved some time before 1845, the year of annexation, was inspired not by the Great Seal of the United States, but by the Mexican legend which tells of a great eagle perched on a cactus plant with a snake in its talons and a berry in its mouth. The snake is missing in this version. The legend is portrayed on the modern flag of Mexico.

With the approach of the twentieth century the handsome eagles

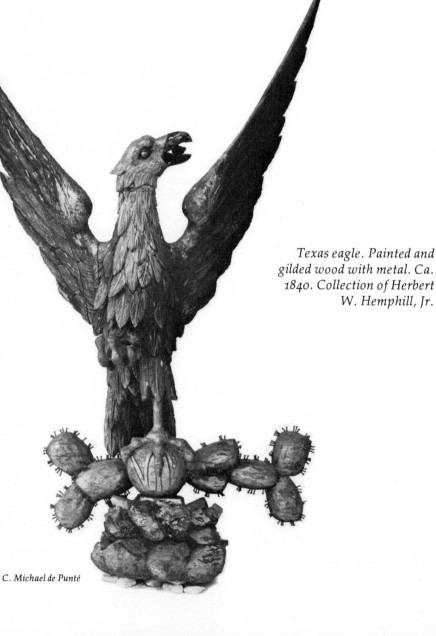

C. Michael de Punté

Texas eagle. Painted and gilded wood with metal. Ca. 1840. Collection of Herbert W. Hemphill, Jr.

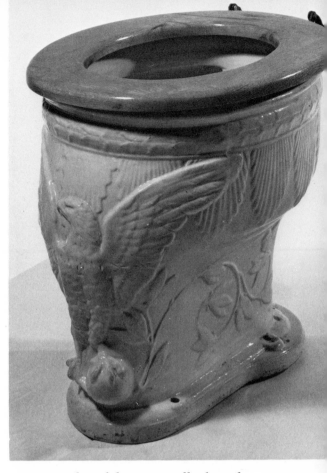

Molded vitreous porcelain toilet. Trenton Potteries. Ca. 1900. Courtesy Smithsonian Institution.

carved to decorate public buildings were replaced by generally banal stone and cast concrete versions. They can be spotted on government buildings and post offices. Ship carvers went out of business with the last of the wooden ships. In the Civil War period most of them turned to carving cigar store Indians and carousel figures.

Odd items appeared from time to time. At the turn of the century this "patriotic" toilet bowl, decorated with an eagle stretching wings of molded porcelain, was custom made, probably for the White House. The glorious national symbol also became a favorite of tattoo artists and their customers.

Today the eagle has been virtually abandoned by painters and needle-workers, but it remains a standby for political cartoonists, poster artists, and folk carvers. The handsome eagle on page 52, with wings doweled into its body, was made by an anonymous carver at the turn of the century.

Our veneration for the eagle as symbol has never related very directly to our treatment of the living bird, and because the once abundantly prevalent raptor was becoming alarmingly scarce, a law was passed in 1940 against killing eagles—a game indulged in for sport, and a precau-

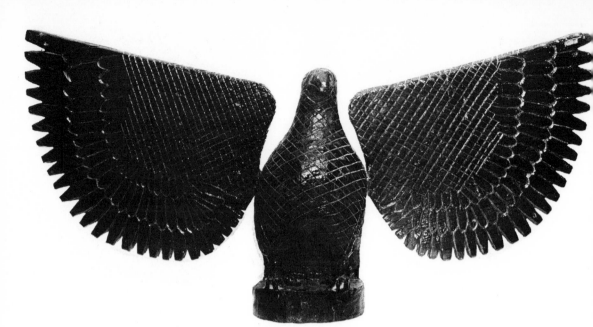

Carved eagle. Ca. 1900. Privately owned.

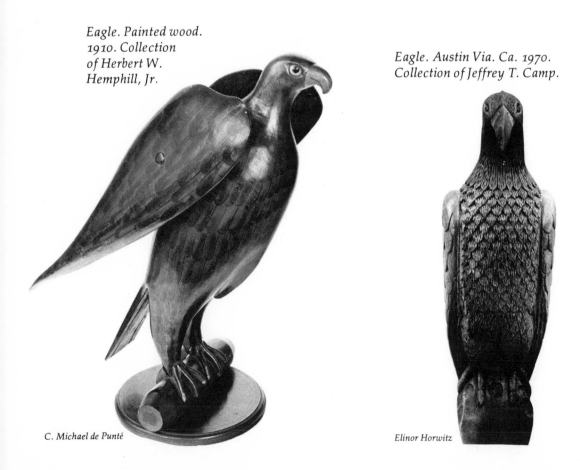

Eagle. Painted wood.
1910. Collection
of Herbert W.
Hemphill, Jr.

Eagle. Austin Via. Ca. 1970.
Collection of Jeffrey T. Camp.

C. Michael de Punté

Elinor Horwitz

tion favored by fur trappers and fishermen who mistakenly thought the bird preyed on valuable foxes and salmon.

Not everyone loves the eagle. On February 14, 1960, an article by Columbia University professor Richard Morris appeared in the *New York Times*. It was titled "Is the Eagle Unamerican?" and was inspired by criticism of an immense sculptured bird with a thirty-five-foot wing-span which was about to be placed on the facade of the then-new United States Embassy in London. As Morris wrote, "A huge bird of prey will cast its sinister shadow upon the statue of Franklin Delano Roosevelt, which stands in the square." He described the eagle as an inappropriate "symbol of imperial might and brute power . . . a lazy creature that prefers a meal of carrion to making its own kill . . . a gangster bird, a highjacker." He suggested instead a new Great Seal with the head of the Statue of Liberty as its symbol. So far no one except perhaps the ghost of Benjamin Franklin has seconded the motion.

The Stars and Stripes

Flag historians note that as early as 4000 B.C. Egyptian ships were decorated with tall poles, topped by figures of symbolic birds or other devices, with strips of colored cloth hanging below. The purpose of the standards was simply identification, as all the ships from a given province adopted the same emblems. Since that time flags of a great variety of shapes and designs have been made and displayed by virtually all peoples, with the notable exception of the North American Indians. During the feudal period in Europe the rites of heraldry decreed that every important person must have a flag to indicate his social and military rank. The famous Bayeux tapestry, which commemorates the Norman invasion of England, is a record of many of the pennants that were carried on the lances of knights in William the Conqueror's army.

The concept of a national flag—one which would represent all the people living within a country—is relatively new. Although flags had long been used as symbols of royal power and religious, tribal, political, or military affiliation, it was not until the sixteenth century—when European explorers began to sail far beyond their coastal waters—that national flags were first used. The idea that flags might be used to evoke patriotic sentiment during periods of national danger arose still later. Today a flag is seen as an emblem of common sentiment, a highly visible

Flag Day. Oil on canvas. William Doriani. 1935. Sidney and Harriet Janis Collection. Gift to the Museum of Modern Art, New York, N.Y. After thirteen years in Europe, Doriani returned to the United States on Flag Day and was inspired to make this painting.

object which can become a rallying point and represent a set of principles or ideals.

The first flag flown in America was the so-called Red Ensign, which had been adopted in England during the reign of Elizabeth I and was brought over by early colonists. Unlike today's Union Jack, it had a solid red ground with a red cross of St. George in the white canton—the square or rectangle in the upper left-hand corner, sometimes called the "union." To the early Puritans of New England, the flag was unacceptable since their religious beliefs forbade reverence to the cross. They transformed the flag by removing the cross, leaving a plain white canton on a red ground. They also set to work stitching up new flags. The result was a gradual accumulation in the thirteen colonies of handmade, hand-designed banners, each representing a militia, a naval contingent, a trading vessel, or an entire colony.

By the time of the Revolutionary War any number of striking flags were in use. The pine tree symbol, with the motto AN APPEAL TO HEAVEN, had been adopted by Massachusetts and was the banner flown at the Battle of Bunker Hill. The design came from the most noted early American coin, the pine tree shilling, which was minted in Boston between 1652 and 1686. The colony of Rhode Island proudly displayed a white flag with a blue anchor and the word HOPE. The beaver became the

symbolic animal on the New York flag, and the South Carolina Navy and the Culpeper, Virginia, Minutemen favored the all-American rattlesnake and the motto DON'T TREAD ON ME.

Some of the new flags were austere, others complex in design. One early flag was simply an unadorned piece of red damask. The flag of the Philadelphia Troop of Light Horse had thirteen blue and silver stripes in the canton and, on the field, an Indian carrying a bow and a liberty pole and cap. The design also included the head of a horse, an angel blowing a trumpet, a shield, and the words FOR THESE WE STRIVE.

The members of the secret patriotic society known as the Sons of Liberty are thought to have been first to use a flag with a striped field. Their flag, of which no examples survive, may, however, have had nine vertical red and white stripes rather than thirteen horizontal stripes. It became a symbol of rebellion after the society's action in the Boston Tea Party, but accounts of its precise design conflict.

This LIBERTY OR DEATH banner, showing a sword crossed with a pole and liberty cap, was actually used in the Henry Clay political campaign of the 1840s, but it derives from the militia flag of White Plains, New

"Liberty or Death." Campaign banner of 1840s based on Revolutionary War flag. Courtesy Smithsonian Institution.

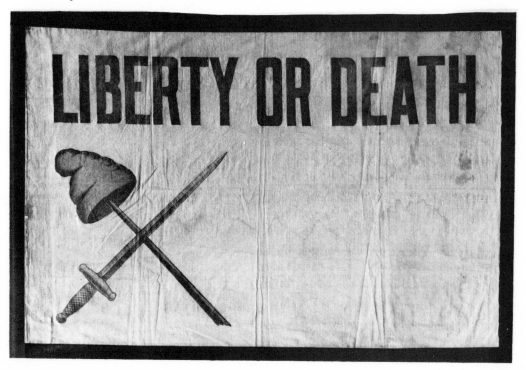

York, used during the Revolution. There were other similar flags, including one known as the Moultrie flag, flown by the South Carolina troops under the command of Colonel William Moultrie. It showed a crescent moon on a dark blue field and the single most evocative word of the time: LIBERTY.

The great number of flags used by the colonies and by American ships at sea confused and irritated many leaders of the day, including General George Washington. "Please fix upon some particular colour for a flag . . . by which our vessels may know one another," wrote his military secretary to those readying ships for battle.

The Grand Union flag, raised by George Washington at Cambridge, Massachusetts, in January 1776, was the design that immediately preceded the Stars and Stripes. As the official flag of the Continental Army, it attracted considerable attention. Like the Stars and Stripes, its field had thirteen alternating red and white stripes. In the canton, however, was the British pattern of mingled crosses.

On June 14, 1777—the date now celebrated as Flag Day—the Continental Congress issued a resolution: "That the flag of the thirteen United States be thirteen stripes, alternate red and white; that the union be thirteen stars, white in a blue field, representing a new constellation." Although the wording of the resolution seemed precise to some, others questioned the meaning of "a new constellation." The thirteen stars were placed in a circle by some flag makers, by others in an oval or in straight lines. Some early flags show nine stripes instead of thirteen. Even the colors show considerable variation. Green and white striped flags still exist, as do flags that have blue stripes mingled with the red and white.

Furthermore, the proper number of points on a star was not at all a matter of common agreement. In the old banners of heraldry the star always had six points. The five-pointed star of the American flag is what in heraldry is referred to not as a star but as a "molet," the symbol for a knight's spur. It is thought that the molet was chosen because it appears on the Washington family coat of arms. Although the molet is often shown with a central hole to accommodate the stem of the spur, the molet-shaped star on the flag eliminated this detail. Early American flag makers interpreted the whole idea with liberal enthusiasm, cutting out six-, seven-, and even eight-pointed stars when the spirit moved them.

Legend grants that Betsy Ross was responsible for the five-pointed star—that the clever flag maker showed George Washington how easy it was to cut out the shape with scissors. The Betsy Ross tale, which is

based solely on family tradition, is given little credence today by historians. That Elizabeth (Betsy) Griscom Ross was a flag maker, born in Philadelphia in 1752, is beyond dispute. In 1870 her grandson, William J. Canby, publicized the story known to schoolchildren throughout the country today. It was alleged in his family that Betsy made the first stars and stripes American flag in June 1776 for a secret group led by George Washington. The design of the flag is said to have been based on a rough sketch which Washington redrew as he sat in her parlor talking with his cohorts. No one has been able to document this tale, although other biographical facts of the flag maker's life are fully substantiated. Despite the doubts of historians, the Betsy Ross legend lives on. She was commemorated on a three-cent postage stamp on January 1, 1952, the date of her two hundredth birthday.

An appliquéd picture of the young Betsy Ross, made by Esther McGrew Hardin of San Antonio, Texas, shows the young seamstress with her spools of thread, pincushion, and sewing box on the table by her side (page 70). A picture of a Revolutionary War soldier hangs on the wall. A pot is being heated on the fire and a cat sleeps cozily on the hearth. Mrs. Hardin, who has appliquéd many historical scenes, likes to point out the pewter teapot, the quill pen, the hooked rug, and the authentic costume of the time. The white cat is made from the inside fleece of an old gray sweatshirt dating from the third quarter of the twentieth century.

The persistence of the Betsy Ross story is due to the fact that no other explanation of the origin of the stars and stripes design has ever surfaced. No counterclaims of any significance have ever been brought forth. One Francis Hopkinson, a poet and artist of the Revolutionary period, claimed credit for having designed the flag and asked, in payment, "a quarter cask of the public wine"—a request that was refused by skeptics in Congress. It is a tantalizing mystery that, whereas many documents survive regarding the various proposals for the Great Seal, nothing is really known about the preliminary debates leading to the choice of the Stars and Stripes, or about the person or persons responsible for its design.

The flag of thirteen stars and thirteen stripes persisted as the official banner until Vermont and Kentucky were admitted to the union in 1791 and 1792. Since the stars and stripes represented the number of states it seemed only logical to add two more stars and two more stripes. From 1795 until 1818 the flag of fifteen stars and stripes was proudly displayed as a sign of the continued growth and strength of the new republic.

The famous battle-tattered star-spangled banner which was flown at Fort McHenry—and which now occupies a place of special prominence at the Smithsonian Institution in Washington, D.C.—is an example of the flag of fifteen stars and stripes used officially at the time of the War of 1812. In 1817, when it was noted that additional states might rise to an ultimate total of twenty and lead to a flag crowded with undignified narrow stripes like a peppermint stick, a new resolution was enacted. The "banner of freedom"—a flag in which stars would represent the number of states but stripes would revert to the original thirteen—was accepted with enthusiasm.

From the year of its origin the Stars and Stripes appeared frequently in folk art, often as part of a composition including other patriotic symbols. In early paintings Miss Liberty is seen carrying a flag—a flag frequently rendered with little reference to official design. The eagle waves a flag

Star-Spangled Banner. Courtesy Smithsonian Institution. This huge flag, originally 40 feet long by 30 feet wide, was flown during the War of 1812 and inspired Francis Scott Key to write "The Star-Spangled Banner."

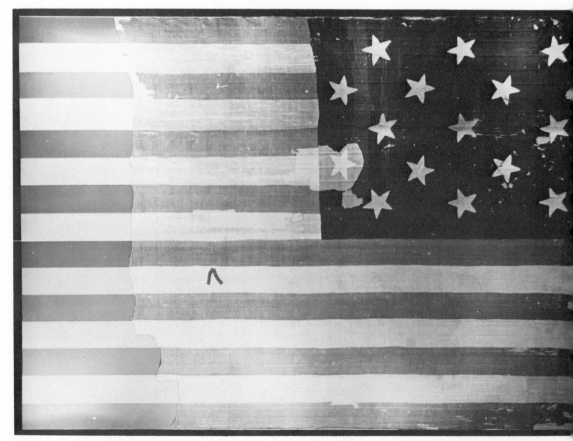

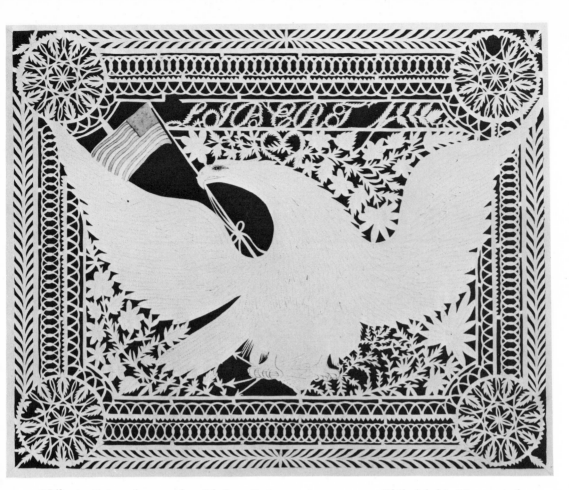

"Liberty," American eagle with flag. Cut paper. 1777–1792. Philadelphia Museum of Art: Bequest of Lisa Norris Elkins.

which he holds in his beak in many representations, including this delicate paper cut, which survives from the late eighteenth century.

Stoneware jugs were frequently incised or painted with a design of crossed flags all through the nineteenth century. The jugs, which held molasses, vinegar, cider, milk, and other staples, are called "salt-glazed" because salt was thrown by the handful into the kiln as the vessels were fired, to combine with the silica in the clay body and form a distinctive mottled grayish glaze. Earthenware first dominated American pottery production, but it was superseded by the more durable and dense stoneware starting in the last quarter of the eighteenth century. The salt glaze replaced the old toxic lead glazes used on porous earthenware, and designs were at first incised and later painted freehand with a mixture of cobalt oxide and silica. Most folk potters relied on pottery shapes and

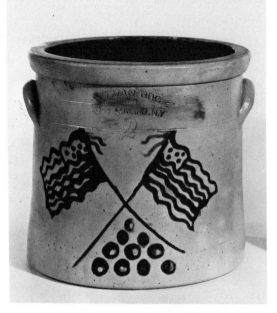

Stoneware jug. Ca. 1875.
Courtesy America Hurrah Antiques,
New York, N.Y.

Flag quilt top. Red, white, and blue appliqué with embroidered stars. Kansas. Late nineteenth century. Courtesy George E. Schoellkopf Gallery, New York, N.Y.

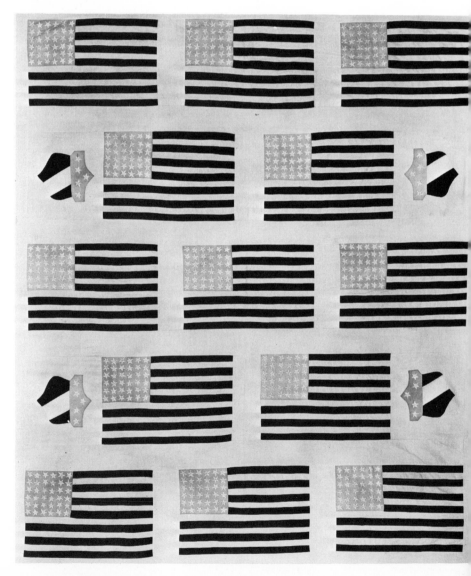

decorative motifs that had been passed on through the generations, and eagles and flags—often accompanied by cannons or, in this case, cannon-balls—were particularly popular. Common stoneware vessels were made until the 1880s along the east coast and, in remote mountain areas where commercially manufactured containers of glass and metal were not available, production continued well into the twentieth century.

Flags were also popular motifs for quilts, and have remained so—on a much more limited scale—in the twentieth century. This nineteenth-century quilt top from Kansas, which was never made into a completed bedcover, combines appliquéd stripes with embroidered stars in a thirty-six-star design.

The flag gate shown on page 66, which seems to ripple in a constant breeze, comes from Jefferson County, New York. It shows the thirty-eight stars which were official from 1877 to 1890. It served for many decades to keep cattle within their pasture and to delight everyone who passed. The wrought iron hinges are of a type frequently used on large barn doors. Another unusual representation of the flag is this weather-vane, made of sheet metal and thought to have been used on either a Masonic Lodge or a Mechanic's Guild Hall in New England.

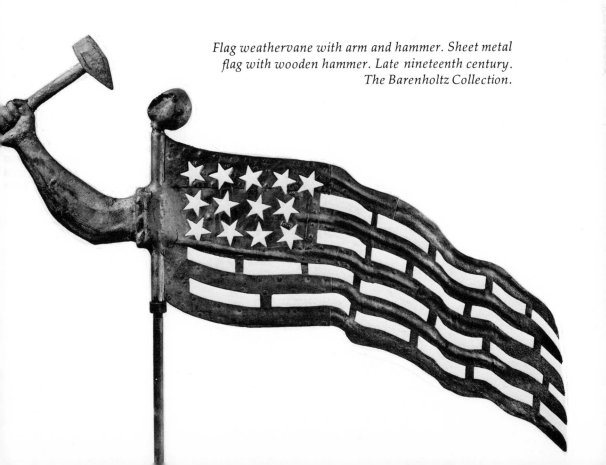

Flag weathervane with arm and hammer. Sheet metal flag with wooden hammer. Late nineteenth century. The Barenholtz Collection.

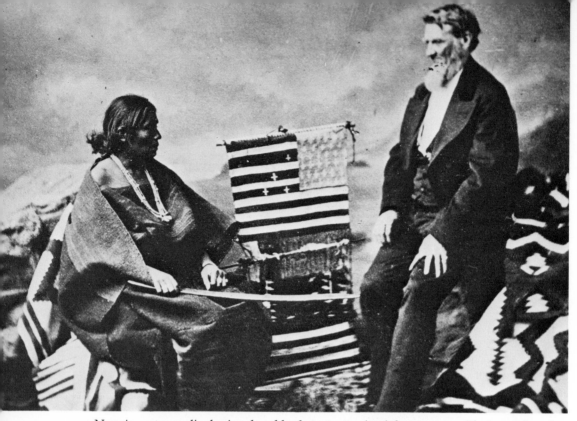

Navajo weaver displaying her blankets to territorial governor. Photograph. 1873
Courtesy Museum of the American Indian, Heye Foundation.

Despite their ill-treatment by the United States government, the Navajo Indians of the southwest have been using the American flag and the eagle of the Great Seal in patriotic pictorial weavings and beadwork since the late nineteenth century. Navajo weavings, which had previously been entirely geometric in design, began showing images of animals, trains, and American flags and eagles in the post–Civil War period. In an 1873 photograph a Navajo weaver named Juanita is displaying her rather unorthodox American flag to the territorial governor, W. F. M. Arny. As is common even today in Indian flag designs, the number and shape of the stars seem purely arbitrary (see also page 67). The 1875 weaving, like many contemporary Navajo rugs, has cross-shaped stars. The rules seem to dictate that flags may have anywhere from six to fifty-one stars (one representing the Navajo nation) and nine to twenty-one stripes, and that the stripes may be colored black and aqua as well as red and white. Stripes also often appear in varying widths, and flags are made in vertical as well as horizontal shape. The Navajo eagles, copied from coins and bills, are equally freely interpreted. Most people believe that the prevalence of patriotic motifs in

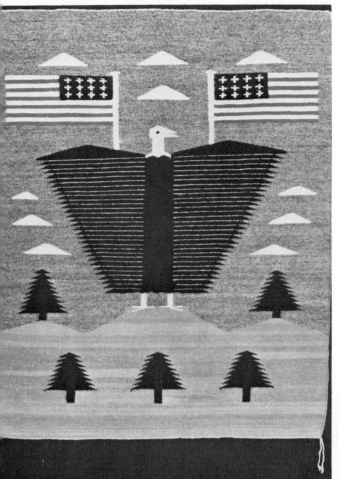

Contemporary Navajo pictorial weaving. Collection of Mr. and Mrs. H. W. Rhodehamel.

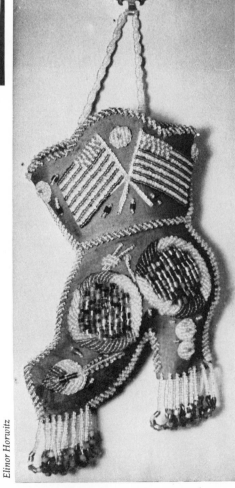

Beaded pincushion and comb holder. Collection of Herbert W. Hemphill, Jr. Items like this were made by Seneca Indians and sold at Niagara Falls in the late nineteenth century.

Elinor Horwitz

Indian beadwork and other arts and crafts of numerous tribes today and a century ago reflects true patriotic feeling, particularly since customers for these wares have traditionally preferred the old geometric patterns.

The use of the colors red, white, and blue—even without the actual flag design—can represent the flag. In a tobacco-growing area of southwestern Virginia a lonely eccentric named Charlie Fields, who was imbued with ardent patriotic sentiments, painted the exterior and interior of his house with geometric designs, squiggles, and polka dots of red, white, and blue. He painted the same decorations on the chairs, tables, clocks, stovepipes, and picture frames; on his many beehives; and on the suit he wore on Sundays when he opened his house to visitors. On the front door he painted a flag (page 68). Fields worked on the house for three decades until his death in 1966.

Fields's house is perhaps the most thorough exploration on record of the effect of red-white-and-blueness, but design variations on the national color scheme can be found in an imaginative abundance. This knitted muffler, featuring stars, stripes, and chevrons, is an expression of the flag image. So is the red, white, and blue abstract pattern on the

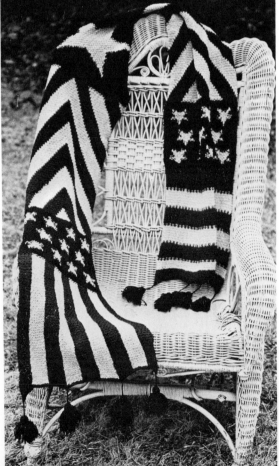

Knitted muffler. 1968. Dinah Stevenson of Hoboken, New Jersey, knitted this red, white, and blue muffler in a design of stars, stripes, and chevrons.

Elinor Horwitz

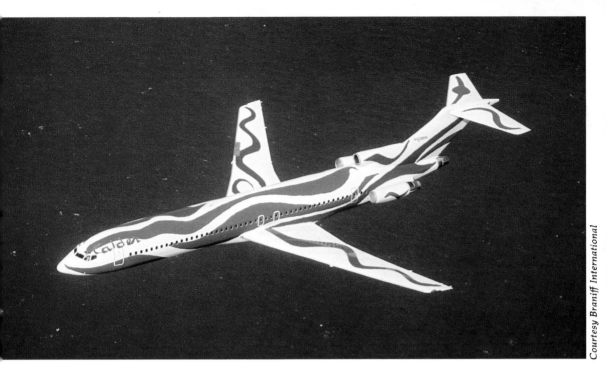

Courtesy Braniff International

Braniff International plane painted red, white, and blue. Design by Alexander Calder. 1976.

Llewellyn Allison

Rappahannock. Flo Duvall of Flint Hill, Virginia, made this needlepoint square based on a design by Eileen Manwaring of Woodville, Virginia. The portrayal of George Washington surveying Washington, Virginia—the county seat of Rappahannock County—has been sewn into a large tapestry displayed in the governor's mansion during bicentennial year.

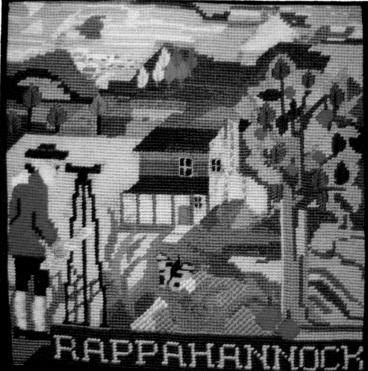

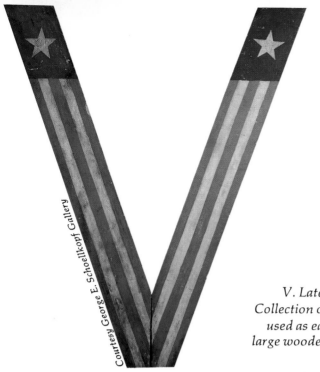

V. Late nineteenth or early twentieth century. Collection of Henry M. Reed. The victory sign was used as early as the late nineteenth century. This large wooden V was probably made for a campaign headquarters.

Flag gate. Wood and metal, painted. Jefferson County, New York. Ca. 1872. Courtesy Museum of American Folk Art, New York, N.Y.

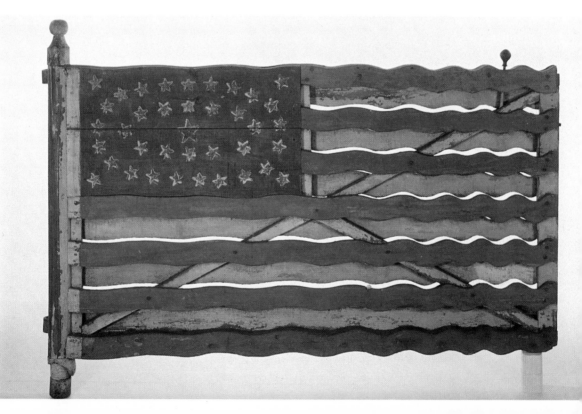

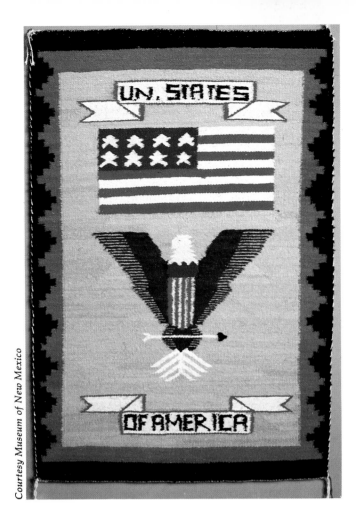

Contemporary Navajo pictorial weaving. Collection of Herbert W. Hemphill, Jr.

Campaign flag. 1880. Courtesy Smithsonian Institution: Ralph E. Becker Collection. This flag was painted by a Pennsylvania folk artist during a local appearance by the candidates.

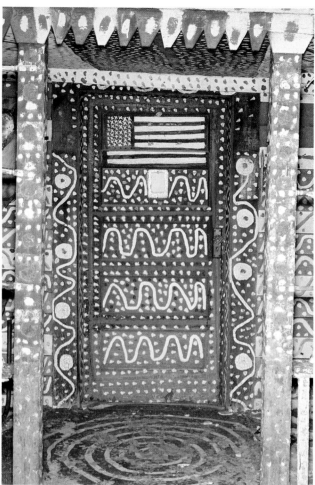

Painted door. Charlie Fields of Lebanon, Virginia, painted this flag on the door of his red, white, and blue polka-dotted house.

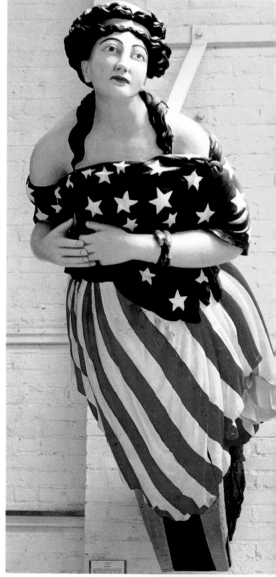

Figurehead from the Benmore. Courtesy Mariners Museum, Newport News, Va. This Scottish ship was built in 1870 with a figurehead of Cleopatra. When it was sold to the U.S. Mercantile Marine Company of New York in 1921, the drapery was repainted to resemble an American flag.

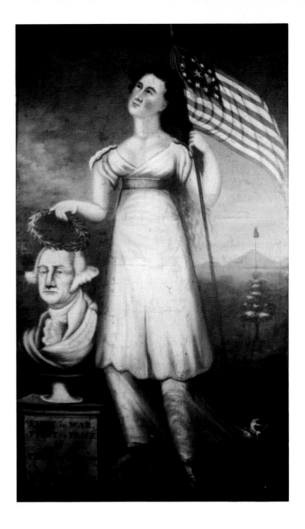

Liberty and Washington. Painting on a window shade from a Connecticut tavern. Ca. 1800. Reproduced through the courtesy of the New York State Historical Association, Cooperstown.

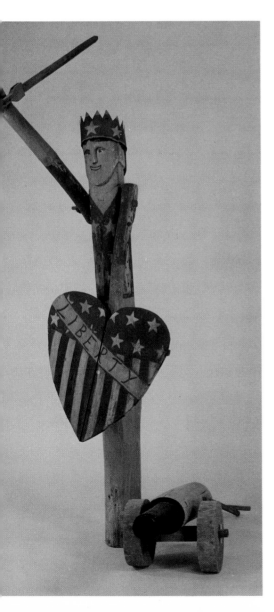

Liberty. Painted wood. Early twentieth century. Collection of Michael and Julie Hall. This figure, 82 inches tall, was carved from a pole and was originally set in the ground.

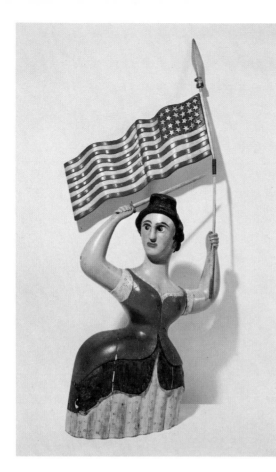

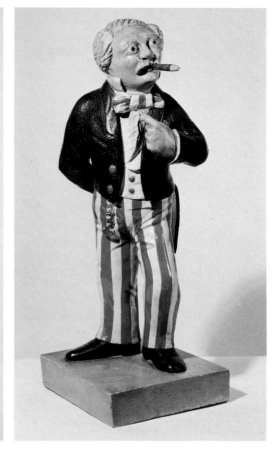

Miss Liberty. Painted wood. From a boat-house at Tuftonborough, New Hampshire. 1850–1860. The Barenholtz Collection.

Uncle Sam. Counter display figure. Painted wood. Late nineteenth century. The Barenholtz Collection.

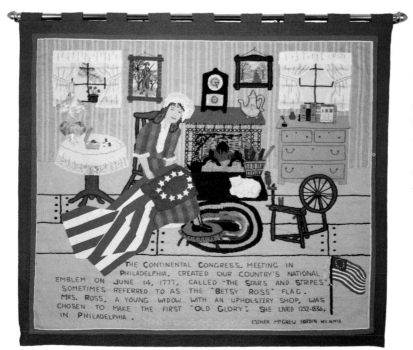

Betsy Ross Making the Flag. Appliquéd and embroidered picture. Esther McGrew Hardin. 1975. Courtesy Fendrick Gallery, Washington, D.C.

George Washington on a horse.
Painted wood. Ca. 1835–1865. Re-
produced through the courtesy of
the New York State Historical
Association, Cooperstown.

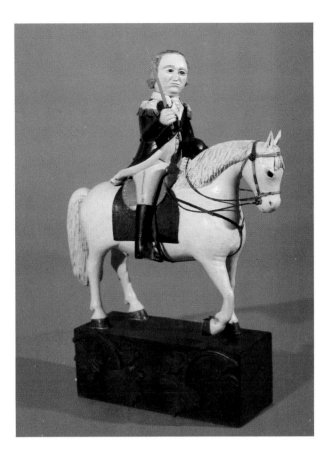

Patriotic panel. Embroidery on silk, dated January 1931. Thalia Nichlan. Collec-
tion of Mr. and Mrs. Elias Getz. Uncle Sam appears to be seated in a theater with
his arm around Miss Liberty.

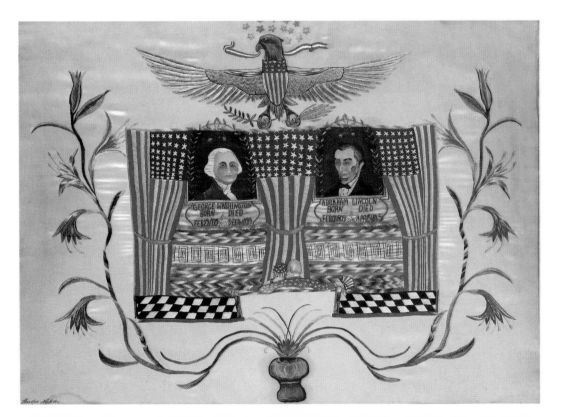

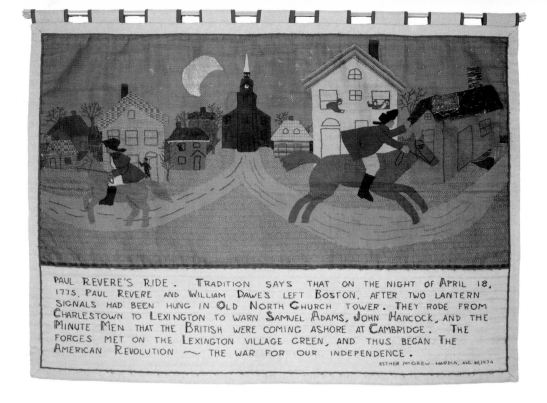

Paul Revere's Ride. Appliquéd and embroidered picture. Esther McGrew Hardin. 1974. Courtesy Fendrick Gallery, Washington, D.C.

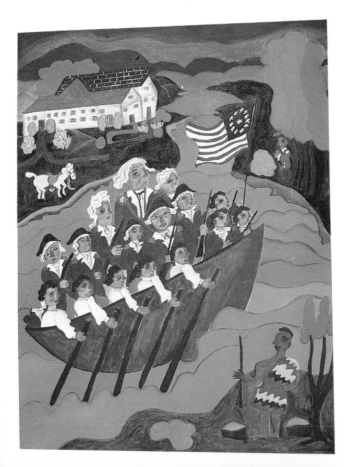

Washington Crossing the Delaware. Oil on Masonite. Malcah Zeldis. Ca. 1973.

Pennant holder. Painted wood. Ca. 1875. Collection of Herbert W. Hemphill, Jr. This handsome pennant holder was used at the Long Island Yacht Club in the last quarter of the nineteenth century.

Elinor Horwitz

Braniff International plane designed by Alexander Calder (page 65). So are many commercially produced fabrics which cater to a fad among young people who make their own clothes.

During the 1960s there was considerable objection to the use of flag-like fabric in clothing and to the sudden appearance of embroidered flags on jeans, shirts, and jackets. Although a critical view of United States foreign policy often *was* intended, particularly during the last years of the Vietnam War, the entire dispute seems now to have been a humorless and crotchety misdirection of "patriotic" concern. In actuality, the entire subject of flag etiquette is a matter of recent history. Our flag code was first framed by a group led by members of the American Legion, meeting in Washington on June 14, 1923—Flag Day. They objected to what they considered undignified uses of the flag as packaging or as a background for advertising mottoes—usually written across the white stripes. Legalization of the code, which lists proper ways of displaying and honoring the flag, did not take place until 1942, when Congress made it official. Many of its regulations would astonish people of a slightly earlier period who considered it both patriotic and entirely

Chair. From a set of six chairs made in Ohio in about 1840 and painted with red, white, and blue decorations in the first half of the twentieth century. Courtesy Michael Black.

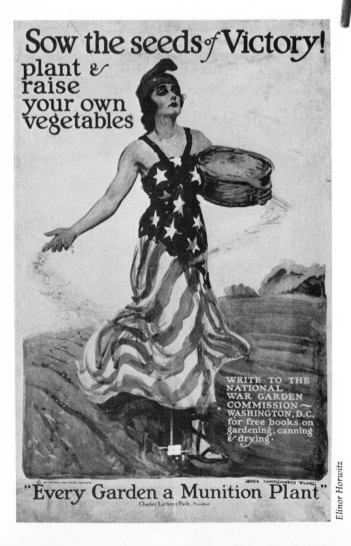

"Sow the Seeds of Victory." World War I poster. James Montgomery Flagg. Collection of Erica Horwitz.

seemly to drape the flag in any fashion that seemed decorative, to wear the flag, or even to sit on the flag.

Uncle Sam traditionally wears clothing that appears to have been made out of flags. Take a look at the carousel figure on the cover. Miss Liberty, shown in this World War I poster, has wrapped the flag into a fetching sarong. The nineteenth-century figurehead on page 68, made for a Scottish vessel, was originally intended to be a figure of Cleopatra, wearing an asp bracelet. When it was later registered in America, the drapery on the Egyptian queen was repainted and she became Liberty, "suitably" dressed in the flag.

One authority on patriotic symbols sees the embroidered flag on the seat of a young man's jeans as evidence of true love of country. "He wouldn't wear such a thing at all if he didn't care," she points out. "He's disappointed in our great country and he wants people to know that he really wants a change."

Miss Liberty

When Patrick Henry proposed as alternatives liberty and death his impassioned challenge echoed in the hearts of a fervently idealistic citizenry. Henry's speeches survive because of their eloquence of expression, but the sentiments he voiced were already dear to colonists restless for revolt, to whom the word "liberty" was a battle cry.

The allegorical expression of a national ideal in the form of a classical female figure had sound historical precedent. Although she was smuggled into America in the 1790s from ancient Greece, appropriately dressed in toga and sandals, America's Liberty figure boasts a genealogical history which includes a sturdy strain of native-born ancestors. Of all our patriotic symbols, the female deity generally referred to as "Columbia," "Liberty," "Miss Liberty," or "the Goddess of Liberty" holds the uncontested distinction of having been first on the scene.

As far back as the seventeenth century the continent of North America was symbolized in English, Dutch, Flemish, German, and Italian prints and atlases by a rather formidable female Indian, probably inspired by Pocahontas. Despite the fact that the settlers themselves used the image of an Indian brave on colonial seals and early weathervanes and later as the device on many state seals, the Indian queen or princess was the dominant symbol of the new land in European publications. She fre-

"America." *Dutch engraving by Jacob van Meurs. Frontispiece to Arnoldus Montanu,* The New and Unknown World, *1671. Courtesy Library of Congress.*

quently appeared in engravings of "The Four Continents," accompanied by her sisters—Europe, Asia, and Africa. She was shown as an Amazonian specimen of womanhood, particularly in the seventeenth and eighteenth centuries—dark-skinned, bare-breasted, barefooted, muscular, sporting a feathered headdress and a short skirt made of feathers or tobacco leaves. She carried—and obviously knew how to wield—a club, a scalping knife, tomahawk, or bow and arrows. Her companions in the lush forests of the new land were rattlesnakes, turtles, and parrots. Sometimes she emptied a cornucopia filled with fruits and treasure, and often she was shown riding on the back of an alligator or an armadillo, looking extremely fierce. The exotic flora and fauna of early prints derived from imaginative interpretations of descriptions of South American jungles rather than from New England forests.

The more gentle-looking and youthful Indian maiden of the second half of the eighteenth century was favored by cartoonists and print publishers here and abroad as a symbol of emerging nationalism. Looks, of course, can be deceptive, and the slender maid was behaving in a most aggressive and belligerent fashion. In depictions of the 1770s a vigorous

Indian princess or Liberty figure leads armies in battle or tramples beneath her feet chains, British lions, British crowns, the key to the Bastille. The Sons of Liberty disguised themselves as Indians at the Boston Tea Party, and one engraving of the time illustrated the scene, showing the Indian princess at the head of the fray. It was titled Liberty Triumphant or the Downfall of Oppression.

To the British, the American Indian princess became the naughty daughter of Mother Britannia as revolution neared. "Oh, the Hussy. She dares me to my very face," says Britannia of her tomahawk-wielding daughter in one cartoon. During peace talks following the war, in an engraving titled The Reconciliation between Britannia and Her Daughter America, the stately mother and the rebellious daughter embrace. "Be a good girl and give me a buss," says Britannia, with her arms outstretched. "Dear Mama, say no more about it," replies a plump Indian girl, who carries a pole with a flag and a liberty cap in place of a weapon.

With nationhood a new Liberty figure emerged. Instead of toting tomahawks she routinely carried the new American flag, poles topped

"The Reconciliation between Britania and her daughter America." English engraving by Tomas Colley. 1782. Courtesy Library of Congress.

77

with liberty caps, or purely decorative shields and spears. She kept company with other patriotic symbols—the first president, the handsome national bird.

The neoclassical revival, which had been enjoying great popularity in England, caught on in the United States in the late 1780s. There was considerable intellectual excitement about the wonders of ancient Greece and Rome, reflected in oratory, in a booming academic interest in the gods, goddesses, and legends of classical times, in a sudden passion for classical architecture and ornament. The American democracy was extolled as a modern recreation of the democracy of ancient Athens. With scarcely a backward glance, and only a few feathers to remind her of her past, the Indian princess stepped into the role of Greco-American Goddess of Liberty. Although she continued to wear a plumed headdress in many depictions right through the first few decades of the nineteenth century, her facial features were no longer those of an Indian, and her formerly dark complexion became light. Her hairdo and her profile changed radically. She was seen resting by fluted columns and urns, bestowing olive wreaths, traveling in chariots. She often appeared accompanied by a new set of sisters: the Goddess of Justice, the Goddess of Wisdom, and a scattering of other classically clad deities.

An engraving of 1796 by Edward Savage titled Liberty, in the Form of the Goddess of Youth Giving Support to the Bald Eagle, has been traced as the source of inspiration for a great number of folk art renditions coupling Miss Liberty and the American eagle. The engraving was based on an earlier academic painting of the Greek goddess Hebe and the god Jove, who was traditionally symbolized by the eagle. It shows a delicate, maidenly Miss Liberty dressed in wafting chiffon, offering a chalice to a thirsty eagle. With her right foot she steps on the key to the Bastille, the symbol of tyranny presented to George Washington by General Lafayette. Off in the clouds a liberty cap tops the pole, which holds an American flag. The British fleet is seen in the far distance leaving Boston Harbor. The engraving was widely circulated and admired—and copied in watercolor, in paintings on velvet executed by schoolgirls, in reverse paintings on glass made in the Orient for the American market.

The thoroughly satisfying painting on page 69, made on a window shade, hung in a Connecticut tavern with eleven others like it. It shows Miss Liberty, the eagle, the thirteen-star flag, the cap—and also the old New England pine tree. Miss Liberty doesn't have a free hand to offer drink to the eagle because she is engaged in holding the flag while

Liberty, in the Form of the Goddess of Youth Giving Support to the Bald Eagle. Steel engraving. Edward Savage. 1796. Reproduced through the courtesy of the New York State Historical Association, Cooperstown.

placing a laurel wreath on a bust of the recently deceased first president. With one dainty foot she tramples the British crown.

Early coins showing the exquisitely classical profile of our new goddess were enthusiastically copied by folk painters and carvers. In 1793 both the cent and half-cent pieces carried a profile bust of Liberty. The 1801 inn sign on page 80 was obviously inspired by the medallion on the coin.

Often Liberty was referred to simply as "America" or as "Columbia"—a feminization of "Columbus" and a name that had once been proposed for the new republic. By either name the goddess remained a "Miss," wore pure white Grecian robes, and later draped herself in the American flag. She appeared bareheaded or with an olive wreath in her hair—or she wore a helmet or the stocking cap, a symbol of freedom, which she had plucked from the top of her pole.

In an early nineteenth-century British engraving she wears classical dress, carries the pole and cap, retains her ancestral plumes, and is

attended by a strange chubby, dark-skinned boy. Her shield is decorated with an animated and very loose interpretation of the Great Seal. Pioneers move west in the background.

In one American painting of the same period she is an engaging bareheaded maiden, who holds a contemporary fifteen-star flag—with an extraordinarily inauthentic number of stripes. The goddess was frequently seen posing thoughtfully near Niagara Falls, the natural wonder which had also been an early symbol of the new land. During the War of 1812 she waved the flag, encouraged an American soldier and a hissing eagle, and looked disdainfully past the British flag, which had fallen to the ground, toward a terrified Britannia and a cowardly lion.

Later in the nineteenth century Miss Liberty enjoyed a vogue as a cartoon figure, sometimes accompanied by her male counterpart, Uncle Sam. She was also considered an excellent subject for the figurehead of ships and she became a favored symbol of volunteer fire companies.

Baltimore's Peale Museum has a number of fine examples of the fire engine art of the 1840s. The old hand-drawn, hand-pump vehicles used by the volunteer fire departments of the time were gorgeously deco-

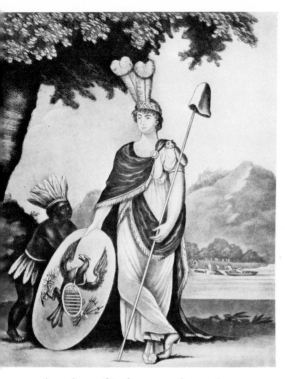

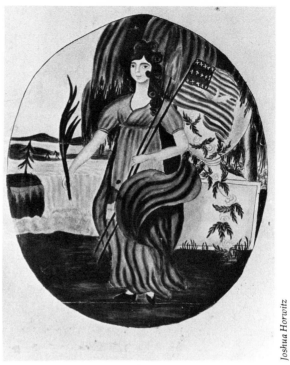

Joshua Horwitz

America. Steel engraving. Anonymous English artist. 1804. Courtesy Philadelphia Museum of Art: Given by Dr. Samuel B. Sturgis.

America. Watercolor. Ca. 1815–1825. Privately owned.

America. Watercolor. Ca. 1815. Reproduced through the courtesy of the New York State Historical Association, Cooperstown. This painting is a symbolic representation of America's successful defense against the British in the War of 1812.

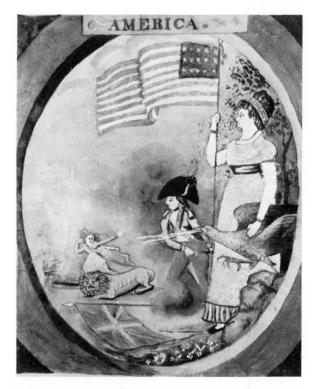

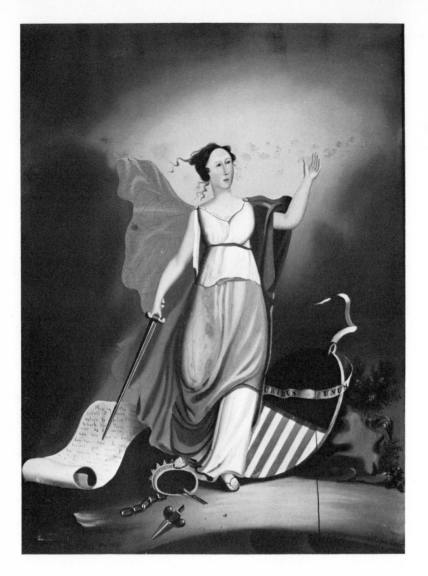

rated, and the companies were named for famous contemporary or historical personages or for such impeccable symbols or ideals as the eagle or Liberty. These two paintings, from Baltimore fire companies of the same period, interpreted the ever-popular figure of our Greco-American goddess in rather different moods. Both are signed by local painters. "Independence," originally part of the hose carriage of the Independent Fire Company, is signed by "Curlett"—probably the painter Thomas Curlett who appears in the 1842 Baltimore city directory. The chaste goddess tramples the symbols of British authority while rigorously pointing out a pertinent phrase in the Declaration of Independence.

The painting of "Liberty," originally a panel decorating equipment of the Liberty Fire Company, is signed "R. H. Sheppard," the name of a

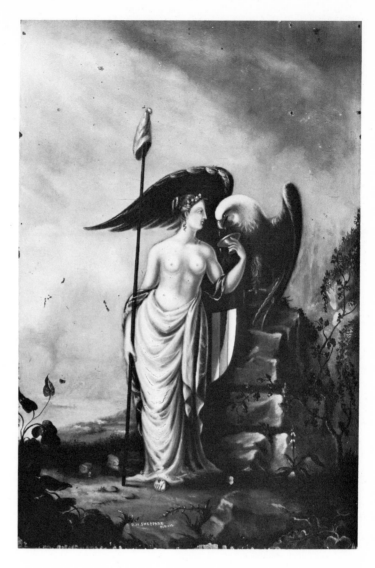

Liberty.
Fire engine painting.
Courtesy Peale Museum,
Baltimore, Md.

painter active in Baltimore from 1842 to 1854. Four other fire engine panels from Baltimore volunteer companies painted by Sheppard are still in existence. Sheppard's Miss Liberty defies the prim Victorianism of the day. Although the painting was directly inspired by the 1796 Savage engraving of Liberty offering drink to the eagle, the lady's drapery has slipped scandalously. She turns a dispassionate Grecian profile toward the handsome bird, but about the corner of her mouth hovers the suggestion of a sensual smile. Miss Liberty had not been seen in such a state of dishabille since her earlier incarnation as the Indian princess, and it's fair to assume that the firemen found her enormously fetching. To some Baltimoreans who saw the handsome pumper at the scene of a fire, the painting must have seemed a sacrilege.

At least one folk carver accepted our symbolic goddess quite seriously as a holy personage. Eliodoro Patete, of Vaste Gerardo, Italy, emigrated to West Virginia in the 1860s and, in an ecstasy of patriotic fervor, carved this seated figure of Liberty in the costume and attitude of an Italian saint. This account is entirely suppositious. It is also possible that he carved a traditional Italian saint figure—and later Americanized her by simply adding the word he had seen on representations of Miss Liberty. Unfortunately no facts are known.

Newspaper cartoons of the mid-nineteenth century often showed Liberty with sword, going forward to battle for American principles. In a carving (page 70) which was made for a boathouse in New Hampshire, the goddess has forsaken her toga. She wears a nineteenth-century costume and, with marvelously aggressive stance, perhaps inspired by a contemporary cartoon, raises the flag and also her sword. Her blue eyes reflect the passion and determination of the Indian maid with tomahawk who long ago threatened Britannia.

Liberty. Seated saint figure. Painted wood. Eliodoro Patete. Courtesy National Gallery of Art, Washington. Index of American Design.

Columbia. Cast zinc.
Manufactured by W. Demuth and Co.
Ca. 1875.
Courtesy Heritage Plantation,
Sandwich, Mass.

Jack Lane

Cast metal Goddesses of Liberty were mass produced by W. Demuth and Company of New York in 1875 and advertised in Demuth's catalogue for $105. Figures such as these were used as lawn decorations and also as ships' ornaments on steamboats, ferries, and pilot boats. They appeared as finials on large buildings and as architectural sculpture in special niches and recesses.

In the nineteenth century all shops, inns, and manufacturing houses advertised their wares with traditional signs or with carved or cast figures. Demuth, a German immigrant and pipe merchant, had started casting tobacconists' figures in metal in 1869. The large carved wood Indians used in front of all tobacco shops during the second half of the nineteenth and the beginning of the twentieth century had to be moved indoors during periods of rainy weather. Demuth was the first to cast Indians—as well as other trade figures—in zinc. He issued impressive catalogs of statues ranging in price from $25 for a three-foot ten-inch Indian maiden to $250 for a six-foot seven-inch "King Lager," a portly, heavily costumed fellow who held aloft an overflowing goblet of beer. King Lager was intended for German taverns or breweries and he was

an imposing figure indeed. With the increased literacy rate of the twentieth century these colorful trade signs disappeared from city streets and several decades later became prized items in museums and private collections.

The factory-produced Demuth figure brought forth a variety of folk art imitations. A photograph of the figure in a book inspired whittler Ed Ambrose of Stephens City, Virginia, to make a Liberty Lady of his own in 1975 (page 91). But in the late nineteenth century, a new prototype of a Liberty figure derived from the Statue of Liberty in New York Harbor made the woman in the stocking cap with the shield seem a little bit . . . dowdy.

The Statue of Liberty, officially titled Liberty Enlightening the World, was designed by the sculptor Frédéric Auguste Bartholdi and was intended as a centennial gift to this country from France. The copper statue's arm and torch arrived in time for the centennial celebration in Philadelphia, where it created enormous excitement. The complete figure took longer to finish than expected, and was set in place on Bedloe's Island and formally dedicated by President Grover Cleveland in 1886. The 151-foot-high figure became, and has remained, our official greeter—the first sight welcoming arrivals to America by ship. The height of the statue greatly exceeds that of the Colossus of Rhodes (100 feet), the famed statue of Jupiter by Phidias (60 feet), and other ancient wonders. Thirty people can stand, without crowding, inside its head, and the torch can accommodate twelve. Men and women of the late nineteenth century were awed by these statistics, and most people of today are too. Thousands—perhaps millions—of tiny souvenir statuettes and postcards have been sold since the unveiling. Photographs of the statue have been seen by virtually everyone in the country.

Suddenly our image of Liberty changed again. The Indian maiden had evolved into a Greek goddess who wore a stocking cap or a helmet and carried flags, shields, liberty poles, swords. Now Liberty had appeared in her largest and presumably most durable incarnation, wearing a spiky crown of rays and holding in one hand a book inscribed with the date of the Declaration of Independence. In her other hand she thrusts aloft a great torch. The figure in the harbor became a new Liberty symbol, which has coexisted with—and rather overshadowed—the Greek goddess. Advertisers at the turn of the century used both with equal enthusiasm to broadcast their wares. Tobacconists were particularly fond of the Statue of Liberty as a symbol of quality.

Weathervanes were ubiquitous in this country from the seventeenth

*Statue of Liberty. Wood. 1890–1900.
Collections of Greenfield Village
and the Henry Ford Museum,
Dearborn, Mich.*

century until the twentieth. Early examples, carved in wood or made of beaten copper, usually featured a cock, in imitation of European designs. Later the Indian archer, the Goddess of Liberty, and the Statue of Liberty came into vogue, along with a codfish and a horse and sulky patterned on one in a popular Currier and Ives print. The most famous American weathervane is Shem Drowne's grasshopper on the cupola of Faneuil Hall, Boston, which dates from 1742, but a few other early vanes still move in the wind on the buildings for which they were designed.

During the second half of the nineteenth century metal weathervanes for homes, barns, and public buildings were made in thriving factories, although folk carvers continued to fashion their own of wood or beaten copper. Even the flag found its way to rooftops (page 61). Vanes made of sheet iron, copper, and other metals were usually painted or gilded. These two vanes show the old and new images of Liberty. The small carved wood Liberty—with staff and flag, olive wreath, and the up-raised arm of the statue on Bedloe's Island—was gilded to make it look like metal. The spirited carving was probably inspired by a weathervane figure.

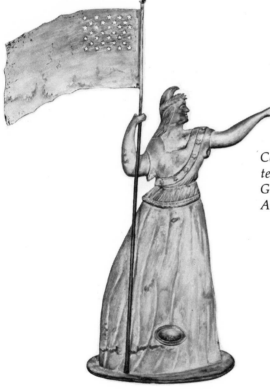

Columbia. Weathervane. Late nine-teenth century. Courtesy National Gallery of Art, Washington. Index of American Design.

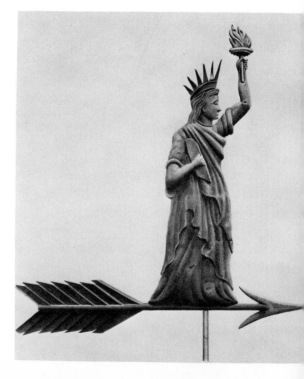

Liberty. Weathervane. Late nineteenth century. Courtesy National Gallery of Art, Washington. Index of American Design.

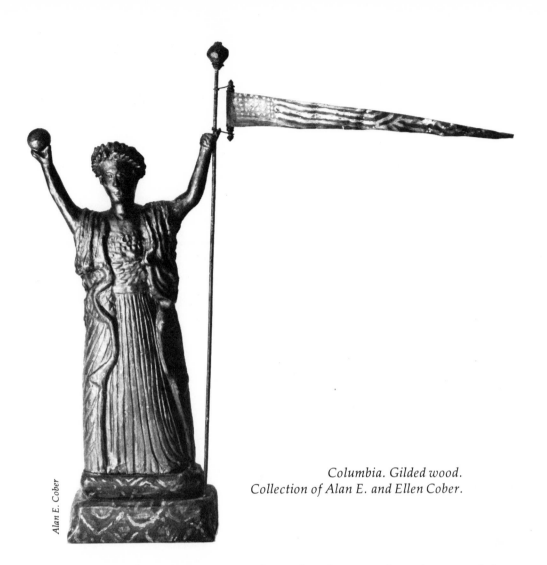

Columbia. Gilded wood.
Collection of Alan E. and Ellen Cober.

In the twentieth century Miss Liberty has become the property of the poster designers and the folk artists. During World War I the most famous poster painters of the period, Howard Chandler Christy and James Montgomery Flagg, depicted Miss Liberty as a shapely, eye-catching contemporary miss (page 19).

The folk artists have brought their own interpretations to the aging symbol. One early twentieth century lady (page 69), carved from a fence post, has enough verve and vitality to lead an army. Elijah Pierce, who is in his eighties and still runs a barbershop in Columbus, Ohio, usually carves from religious inspiration, but he has made his own rugged Statue of Liberty. Leslie J. Payne, a retired fisherman from the Chesapeake Bay shore in Virginia, made a painted sheet iron figure and dubbed her The New York Lady. Payne says he saw the Statue of Liberty from a bus on his only trip to New York and the memory remained with

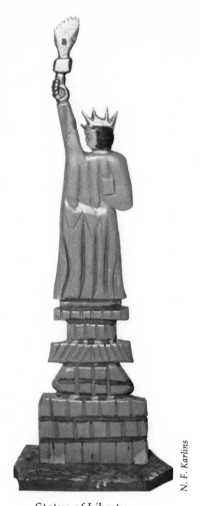

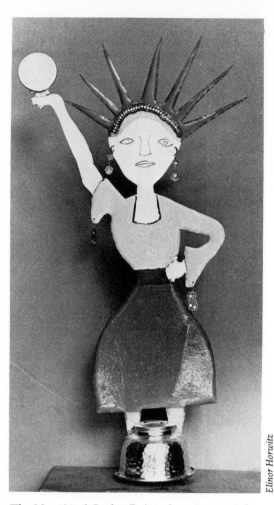

N. F. Karlins

Elinor Horwitz

Statue of Liberty.
Elijah Pierce. 1971.
Collection of Mr. and
Mrs. Sterling Strauser.

The New York Lady. Painted roofing metal
with costume jewelry. Leslie J. Payne. Collec-
tion of Jeffrey T. Camp.

him and stirred him to create his own facsimile. "I remember what she
looked like, so I just done it," he says.

Ed Ambrose drew his inspiration from a plate in a book which
showed the Demuth cast metal Liberty figure of the nineteenth century.
Ambrose, who has also recently carved other patriotic pieces—Abraham
Lincoln (page 141) and Uncle Sam (page 104)—feels comfortable whit-
tling any type of masculine figure, but—with the exception of a carving
of a woman in a general store scene and a carving of Mary Magdalen—he
had never attempted a woman before. "I made Mary Magdalen for my
niece for Christmas, and I put her with her head bent over in sorrow

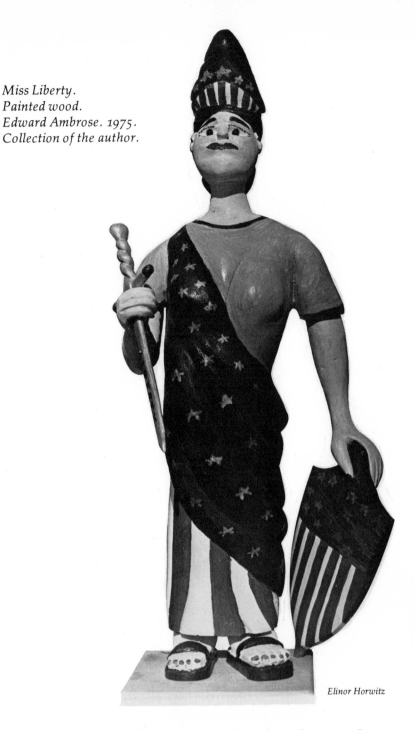

Miss Liberty.
Painted wood.
Edward Ambrose. 1975.
Collection of the author.

Elinor Horwitz

covered with her hand so I wouldn't have to do a face, because I can't carve women." When he undertook the Liberty figure he accepted the challenge. "My, she is some fierce. She doesn't care about no one," he says in admiration, looking at the completed figures. "She's a haughty-looking thing, I'll tell you."

Uncle Sam

When "Yankee Doodle" put a turkey feather in his cap and rode into town on his pony, a wit of the period—a British army surgeon named Dr. Richard Shuckburgh—wrote a ditty describing the scene. He set it to the tune of a song everyone knew, "Lucy Locket Lost Her Pocket," and before long it was a popular hit. The time was 1758, the period of the French and Indian Wars, and "Yankee Doodles" were rough rural fellows or itinerant craftsmen who traveled the roads between New England towns and villages. The name "Yankee" had been bestowed on early English colonists by the Massachusetts Indians. A "Doodle" might be a doodler—perhaps better described as a jack-of-all-trades.

The song was lively and amusing and everyone was delighted by the notion of a New England bumpkin calling himself "macaroni"—the current slang word for a dandy. In the 1770s handsomely outfitted British soldiers hooted the words in derision as hostilities increased. In response, embattled farmers sang the song joyously as they marched to enlist. Yankee Doodle became a hero—a tough young colonist lacking sophistication but ready to fight for his freedom. Almost one hundred years later, during the Civil War, northern troops would join in the old favorite as they marched.

In the early twentieth century vaudevillian George M. Cohan wrote and performed the rousing lyrics, "I'm a Yankee Doodle dandy, a Yankee Doodle do-or-die." Cohan, who was actually born on July 3, 1878, rather than on July 4 as claimed in the song, dubbed himself "a real live nephew of my Uncle Sam." In actuality, despite his white hair and beard, Uncle Sam is considerably younger than the perpetually boyish Yankee Doodle.

American patriots during the Revolutionary War were referred to as "Yankee Doodles"—and also as "Brother Jonathans." Although Yankee Doodle was a purely verbal invention, Brother Jonathan became the subject of drawings and cartoons early in the nineteenth century. Just as the Indian Princess had been portrayed by the British as the daughter of Britannia, so Brother Jonathan was often shown as the unsophisticated son or younger brother of the mature British masculine symbol, John Bull. Like Yankee Doodle, Brother Jonathan was a hayseed. He was an amusing and often preposterous young man who affected striped pants

and a tailcoat and wore a top hat rather than a cap adorned with turkey feathers.

A character generally referred to as "Yankee Jonathan" became a standard comic role in theatrical productions starting shortly after the Revolution. In countless plays, skits, and songs, he arrived in the metropolis in a state of astonished bewilderment, humorously displaying his naiveté and his endless curiosity. But he was an independent and jaunty young man at the same time—a fellow who was capable of fighting for the right, of making heroic rescues, of outsmarting city folks with his old-fashioned country wisdom. The stock character reached his heyday in the 1830s and '40s and continued to appear regularly on stage until the Civil War period.

Brother Jonathan, alias Yankee Jonathan, alias Yankee Doodle, was "a true blue son of liberty," in the words of the first stage Jonathan, but he was hardly a dignified symbol for the proud new nation. Miss Liberty, immaculate and graceful in her flowing white garments, stepped daintily into the nineteenth century, secure in her status as a national emblem. But surely no one would pair her with such an undignified figure as the Yankee!

Jonathan survived, as an increasingly overshadowed figure, through much of the nineteenth century, but by the end of the Civil War he had virtually disappeared. He was gradually but permanently eclipsed by Uncle Sam, that upstanding, spry, and lovable old man who became the enthusiastically acclaimed masculine symbol for the nation. Although it took a while for the beloved uncle to attain full national recognition, he had been born—full-grown, even elderly—during the War of 1812. Of our major patriotic symbols, he is the newest.

Yankee Doodle remained a character in a song and for a short span lent his name to a popular magazine. Jonathan, with his youthful good humor, appeared in cartoons and on the stage. Both figures were always associated with the northeastern part of the country. Uncle Sam, however, came to stand for the United States government. Today no political cartoonist could survive without him. He is instantly recognized here and abroad as the authoritative and forceful spokesman for the ideals and interests of the United States. In the last quarter of the twentieth century Miss Liberty seems a bit bland. She appears now and then on a document or a poster looking rather old-fashioned. But Uncle Sam—as seen in newspaper cartoons almost daily—means business.

Unlike Yankee Doodle, Brother Jonathan, and Miss Liberty, he owes his name and his origins to an actual man. The original Uncle Sam was a

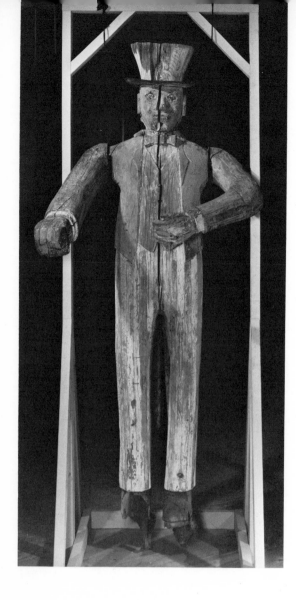

Uncle Sam. Painted wood. Ossipee, New Hampshire. Ca. 1840. Courtesy Museum of Fine Arts, Boston: Harriet Otis Cruft Fund. This 8-foot-tall carved figure is one of the earliest showing Uncle Sam with a top hat.

Uncle Sam. Trade sign. Papier-mâché. Mid–twentieth century. Courtesy American Folk Art Shop, Washington, D.C.

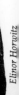

man named Samuel Wilson, who was born in Arlington, Massachusetts (which was then named Menotomy) in 1766. He was nine years old when Paul Revere rode by his house toward Lexington on the famous ride, and several of his older brothers fought in the Revolution. When Samuel was fourteen his father bought a farm just over the state border in Mason, New Hampshire. The family lived there until 1789, when Sam and his brother Ebenezer set off to find jobs in New York State. The two young men soon settled in Troy, New York, where they went to work making bricks. In 1793 they started what became a profitable meat-packing business. They made wooden casks to hold their products, and butchered and salted and packed the meat for sale. The enterprising and capable Wilson brothers soon employed many helpers and ran news-paper ads assuring customers that they could "kill, cut, and pack 150 head of cattle per day."

During the War of 1812, when the northern troops under General Henry Dearborn set up headquarters near Troy, Sam Wilson hastily bid for a government contract to supply meat to the troops. He was granted the job and also another assignment as inspector of beef and pork for the army. When Wilson completed an inspection or made a delivery to the camp, he stamped all casks of salted beef intended for consumption by the troops "U.S.", as an abbreviation for United States. The common contemporary abbreviation for United States was "U. States" rather than "U.S." and the stamp led to general confusion.

Wilson was a very amiable man, a man who loved a joke, and a famed storyteller. Apparently he was called "Uncle Sam" by his many nieces and nephews and also by townspeople and friends up and down the Hudson Valley, where he sold his wares. Because he was so well known and well liked, men seeing the stamp on his casks said their provisions came from "Uncle Sam." They soon started referring to themselves as Uncle Sam's soldiers in much the same way as, over a century later, World War II servicemen named themselves after an official stamp—G.I.s, short for "Government Issue."

The original Uncle Sam became active in Democratic politics in later years, and he remained a leading citizen of Troy and a popular toastmas-ter at political and social gatherings. He died in his nineties, and at the time the story of his link to the figure of Uncle Sam appeared in news-papers in Albany and New York City. He lies today under a large monu-ment, installed by a granddaughter in 1931, which says: "In loving memory of 'Uncle Sam,' the name originating with Samuel Wilson

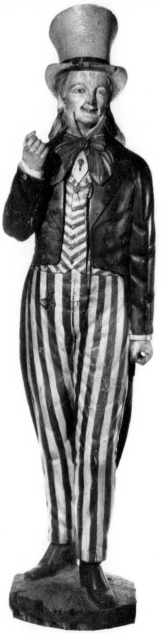

Uncle Sam or Brother Jonathan.
Cigar store figure.
Painted wood. Ca. 1890.
Collections of Greenfield Village
and the Henry Ford Museum,
Dearborn, Mich.

1766–1854—during the war of 1812 and since adopted by the United States."

Although Uncle Sam has been represented by folk artists for a hundred years, it was the cartoonists who made him univerally known. Like the Uncle Sam of present-day cartoons, Sam Wilson was tall, lean, and high-cheekboned, but in the cartoons which appeared before the Civil War, the symbolic figure was portrayed quite differently. In 1832 a lith-

ograph titled Uncle Sam in Danger appeared and had wide circulation as a broadside. In the cartoon, which is an attack on Andrew Jackson's attempts to destroy the Bank of the United States, Uncle Sam appears as a middle-aged, clean-shaven, dark-haired man with a round face, wearing a vest with stars and a striped cloak and nightcap.

In this cartoon on the same subject, Uncle Sam, who is still ailing, wears a nightcap with a headband saying LIBERTY and a flaglike robe. He holds a list of bank failures. His hair is white and he reclines in a chair, as his comforters offer quack remedies. (Secretary of State Martin Van Buren is the figure dressed as a kind old aunt.) The eagle speaks of flying to Texas to avoid starvation, Washington's head falls from a pedestal, and outside the window Brother Jonathan greets the arriving doctor. This cartoon is particularly unusual in that it shows Brother Jonathan

"Uncle Sam with La Grippe." Lithograph. Henry R. Robinson. Ca. 1838. Reproduced through the courtesy of the New York State Historical Association, Cooperstown.

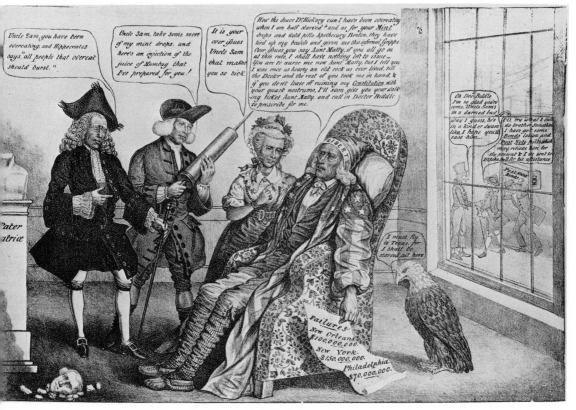

and Uncle Sam together. Jonathan here represents the common man, Uncle Sam the United States government.

The increasing use of lithography in the 1830s resulted in a great output of such cartoons and caricatures, which were printed and distributed on street corners and posted in inns and taverns. Uncle Sam was more and more commonly seen—looking just about any way the artists chose to depict him. He is shown as a young man, an old man; slim, portly; dressed in a variety of fashions.

Brother Jonathan disappeared from American cartoons, but he continued making regular appearances in the British periodical *Punch* as a gawky young man, still the problem child of John Bull. In a harshly critical *Punch* cartoon of 1848 he smokes a cigar, holds a shotgun, and sets his julep down on a table as he watches Liberty, who holds a mask over her face, whip a cowering slave. Jonathan is saying: "Oh, ain't we a deal better than other people! I guess we're the most splendid example to them thunderin' old Monarchies."

In Currier and Ives cartoons of the 1860s Uncle Sam is a clean-shaven gentleman dressed in the garments of the Colonial period, who looks astonishingly like Benjamin Franklin and is often paired with Columbia.

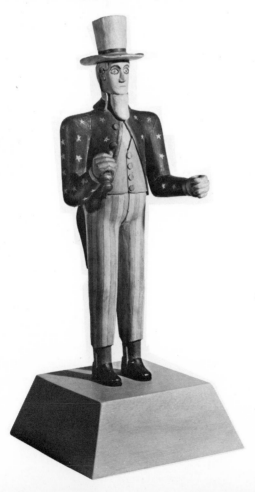

Uncle Sam. Painted wood.
Late nineteenth century.
The Barenholtz Collection.

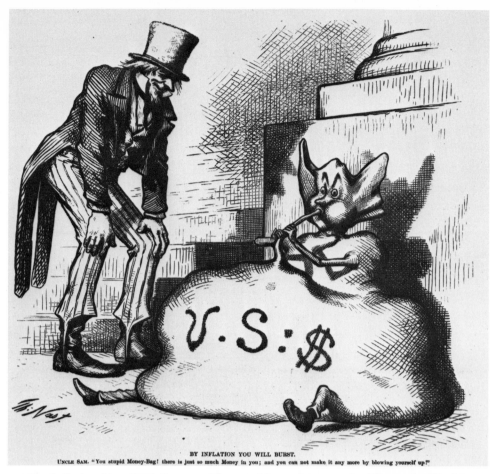

BY INFLATION YOU WILL BURST.

UNCLE SAM. "You stupid Money-Bag! there is just so much Money in you; and you can not make it any more by blowing yourself up!"

"By Inflation You Will Burst." Thomas Nast. Cartoon for Harper's Weekly, *December 20, 1873. Courtesy Smithsonian Institution: Ralph E. Becker Collection.*

The standardized appearance of the figure of Uncle Sam, which is recognized today around the world, was the invention of the famous cartoonist Thomas Nast, who worked predominantly in the Civil War and postwar period.

Thomas Nast came to this country from Germany as a young child. His extraordinary ability was recognized early. By the age of fifteen he was drawing caricatures for *Frank Leslie's Illustrated Magazine* and soon he was also contributing to *Harper's Weekly* and the *New York Illustrated News.* He is generally considered the originator of the modern political cartoon style, and surely no political cartoonist in history has ever wielded such influence. Although the claim is often disputed, Nast is widely credited with having created the Republican elephant and the Democratic donkey. He is best known for his series of cartoons attacking

Tammany Hall and the unscrupulous New York political boss William M. Tweed, and is credited with the breakup of the Tweed Ring.

Nast drew Lincoln (page 135), and he drew a Lincolnesque Uncle Sam—tall, thin, hollow-cheeked, and bearded. After the war another famous cartoonist named Joseph Keppler also portrayed a lanky, bearded Uncle Sam. Nast continued to draw Uncle Sam, often accompanied by Miss Liberty, and on one occasion he drew himself. During a governmental crisis he appeared—rotund, with bristly black hair and whiskers—squirming in a chair in a waiting lobby in the White House. A tall Uncle Sam in top hat, waistcoat, striped pants, and boots holds the famous impatient cartoonist forcibly in his seat, saying with a paternal strictness, "Our artist must keep cool, and sit down and see how it works."

Uncle Sam also appeared in other forms during the mid- and late nineteenth century. He was a popular trade sign figure and could be found in various postures inside and outside the shops of tobacconists and other retailers. An amusing counter figure (page 70) of a chubby, hatless, beardless, cigar-smoking uncle Sam is evidence of the fact that the Nast stereotype was not accepted by everyone. Advertisers used Uncle Sam in posters to lend authority to their claims of excellence. He was commonly shown on political badges endorsing candidates for office (see page 145). Glass factories added Uncle Sam to their list of patriotic specialties. This battleship mustard pot with Uncle Sam riding on top appeared commonly on grocers' shelves.

Elinor Horwitz

Uncle Sam battleship. Milk glass mustard container. Courtesy Sandwich Glass Museum, Sandwich, Mass.

Carousel seats, in which people who were too dignified or infirm to mount a horse rode round and round, often had patriotic themes. The extraordinary representation of Uncle Sam on the cover, dressed in flags and accompanied by the eagle, dates from the late nineteenth century.

Uncle Sam also appeared on the covers of sheet music of patriotic or campaign songs, on weathervanes, on whirligigs, and, with great popularity, on toy banks. Mechanical cast iron banks were first made in 1869, and they became such a fad that during the next thirty years many patents were taken out in fierce competition between manufacturers. This Uncle Sam bank was one of the most successful designs. Put a penny in his hand and give his arm a slight push and the sachel opens to receive the penny as Uncle Sam's mouth moves and his goatee wobbles.

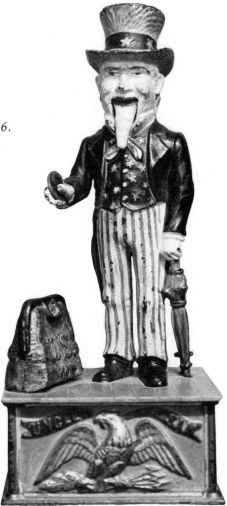

Uncle Sam bank. Patented 1886.
Courtesy Heritage Plantation,
Sandwich, Mass.

Elinor Horwitz

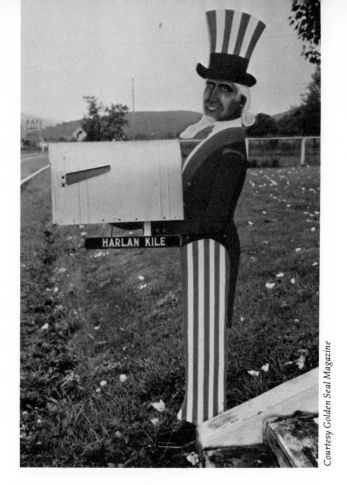

Courtesy Golden Seal Magazine

Uncle Sam mailbox holder.
Painted wood.
William Ruddle. 1970.

The first Uncle Sam mailbox holders were made in the period of resurgent patriotism which followed the Spanish-American War. They continue to be made today in rural areas. Country whittlers have fashioned silhouetted figures of Uncle Sam with arms extended to hold a mailbox in a great variety of original styles. Cast iron figures from the early part of the century can also be found. This Uncle Sam mailbox holder was made during the past ten years by a retired elderly man who had probably seen similar examples in childhood.

James Montgomery Flagg, the most famous poster artist of the World War I period, created the picture in which Uncle Sam, with grave and commanding expression, points straight out from the Army recruiting poster saying I WANT YOU. The lean, stern face of Uncle Sam bears a marked resemblance to that of the artist. The illustration was originally painted as a cover for *Leslie's Weekly*, but it soon became the most famous poster in our history. Flagg's Uncle Sam became so well known that one year later another artist copied his figure for a Prohibition poster. Nast had drawn the form and costume we've associated with Uncle Sam for over a hundred years, but James Montgomery Flagg first

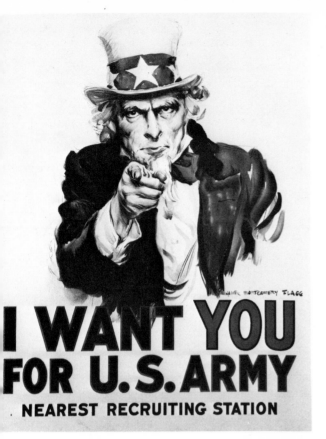

"I Want You For U.S. Army."
World War I Army recruiting
poster. James Montgomery
Flagg painted this most famous
of all recruiting posters. Cour-
tesy Smithsonian Institution.

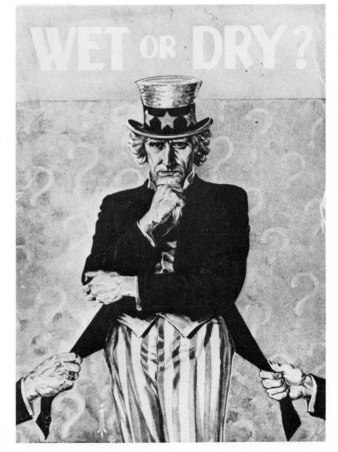

"Wet or Dry?" Poster. 1918.
Courtesy Smithsonian Institution:
Ralph E. Becker Collection.

showed us the gesture which—for many carvers in particular—has become the way Uncle Sam must be posed. These three striking contemporary examples vary in size from fifteen inches to eight feet, but each one points with great strength and authority. Ed Ambrose, carpenter and whittler of Stephens City, Virginia, made his Uncle Sam because he was inspired by the approaching bicentennial. Edgar Tolson, a noted folk carver from Campton, Kentucky, has carved many Uncle Sams, ranging in height from eighteen inches to life-size. Douglas Amidon, wood car-

Uncle Sam.
Edward Ambrose.
1975.
Collection of
the author.
15 inches tall.

Uncle Sam.
Edgar Tolson.
1969.
Collection of
Michael and Julie Hall.
25 inches tall.

Joshua Horwitz

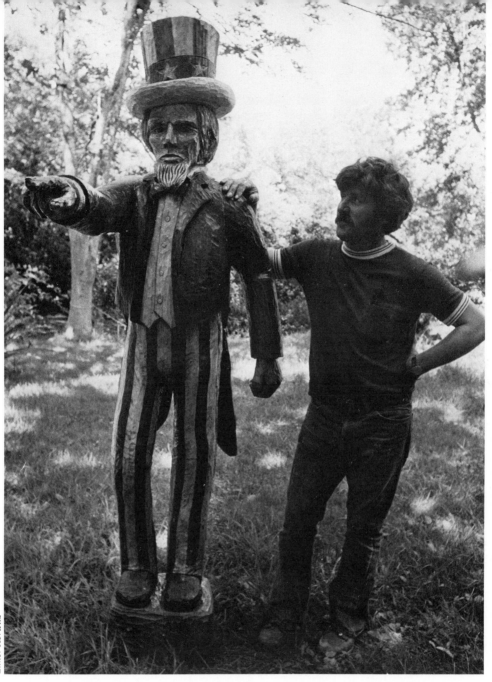

Uncle Sam. Painted wood. Douglas Amidon. About 8 feet tall.

ver of Sandwich, Massachusetts, made this tall Uncle Sam as a trade sign to stand in front of his shop.

Today's cartoonists have no intention of releasing Uncle Sam from his duties as the most vital symbolic representation of the country. But at

least one artist, sensitive to the polarization that made "patriotism" a dirty word in many circles during the 1960s and '70s, has vividly recorded the spirit of the times. Washington, D.C., cartoonist and illustrator John Heinly brought back Miss Liberty—who is seldom seen these days—to stand before the audience along with Uncle Sam and duck the tomatoes.

Ducking the Tomatoes. Ink drawing. John Heinly. 1975.

Patriotic Folk Heroes

To include patriotic folk heroes—actual people who lived within the past two hundred years—in a book about symbols may not be entirely legitimate. Of all the presidents, statesmen, and military leaders who have been viewed as patriotic heroes, only George Washington can be fully accepted as a man whose face became an immediately recognizable symbol. When, during a mid-nineteenth-century crisis in government, a cartoonist drew a picture of a marble portrait bust of the Father of Our Country falling from a pedestal and shattering (page 97), everyone got the point immediately. When a portrait painter of the Civil War period showed Lincoln posing with his generals—and then popped George Washington into the picture to bestow approval on the living president with a consoling gesture (page 137)—the point was made again. We are not really looking at portraits of the man named George Washington in these instances—but at a symbolic figure who stands for the country and its past.

Lincoln, Theodore Roosevelt, and John F. Kennedy are also given notice here because, like Washington, they became favorite subjects of folk artists during their terms of office and on through the years to the present. Lincoln, who was plagued with enemies during his lifetime, was the first president to be assassinated, and his martyrdom, which coincided with the conclusion of the Civil War, led to his deification. (The assassinations of McKinley and Garfield, men who lacked the personal magnetism of Abraham Lincoln, inspired a large production of memorial glassware, handkerchiefs, cheap painted plates, and—in the case of McKinley—a country folk music song called "White House Blues." Very little appeared in the area of folk art.) Paintings and carvings of Theodore Roosevelt and John F. Kennedy, made by self-taught painters and carvers who chose their subjects because of an irrepressible devotion, far exceed the number of portrayals of any other twentieth-century figures.

Fireman's hat, Franklin Hose Company. Courtesy National Gallery of Art, Washington. Index of American Design. Volunteer fire companies of the early nineteenth century were often named after patriotic figures.

There were, of course, a great number of celebrated personalities who became subjects of folk and popular art all through our history. Next to Washington, Benjamin Franklin was the most frequently portrayed of the founding fathers. He appeared on Toby jugs, in paintings and carvings, on the hats and signs of volunteer fire departments who named their companies for him. He is still considered a most attractive subject by such twentieth-century admirers as carver Douglas Amidon.

Benjamin Franklin. Wood. Douglas Amidon. Sandwich, Mass. 1975.

Sergio Balegno

General Marie Joseph Paul Yves Roch Gilbert du Motier, Marquis de Lafayette, the Frenchman who became a Revolutionary War hero, was venerated in this country. Portraits of Lafayette were made by folk artists after the war and well into the nineteenth century. He appeared with Washington in many paintings and on the obverse of a 1900 coin known as the Washington-Lafayette silver dollar.

Portrait of General Lafayette. Pastel. Ca. 1810. Courtesy Philadelphia Museum of Art: Edgar William and Bernice Chrysler Garbisch Collection.

Heroes of the War of 1812 were commonly portrayed alone or in battle—in paint, in wood, in pottery—even on furniture.

Frontier heroes—including those largely created by folklore and by the popular press—were looked upon as symbols of the rip-roaring western movement and the type of American many people wished to be. Davy Crockett, Daniel Boone, and Buffalo Bill Cody were, and still are, the favorites of people working in a large range of media—including chocolate!

Perhaps the only woman who ever emerged as a major patriotic folk image is Betsy Ross. Despite the fact that historians find little concrete evidence for the legend that the Philadelphia seamstress did indeed

Desk. Painted pine. Pennsylvania German. Ca. 1825.
Courtesy Philadelphia Museum of Art: Titus C.
Geesey Collection. War heroes were often shown lift-
ing their hats in this fashion. See the early painting of
George Washington (page 117).

Cigar store figure. Ca. 1860. This figure is generally
considered to be a depiction of Daniel Boone. Cour-
tesy National Gallery of Art, Washington. Index of
American Design.

Buffalo Bill. Painted wood.
1880–1890. Courtesy Heritage
Plantation, Sandwich, Mass.
William F. "Buffalo Bill" Cody,
the famous frontiersman, also
staged Wild West shows, which
is probably what he's doing
here.

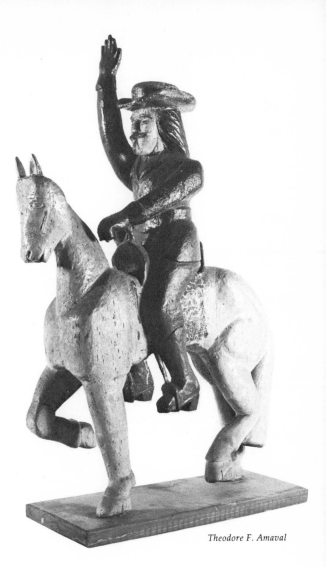

Theodore F. Amaval

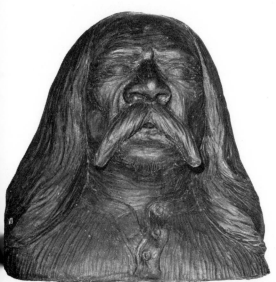

Buffalo Bill. This head of Buffalo Bill was
carved from a large block of Swiss chocolate
by pastry chef Franz Eichenauer of the Fair-
mont Colony Square Hotel in Atlanta. Deco-
rative carvings in chocolate, lard, sugar,
and ice are traditional culinary arts, but por-
traits such as this are rare.

make the first flag, the story has caught the imagination of many folk artists. Since the Betsy Ross legend only came to light in 1870, she was a particularly popular subject during the centennial year.

Civil War generals—most notably Ulysses S. Grant and Robert E. Lee—were certainly patriotic heroes in the minds of a great many Americans, but little folk art depicting them survives. Perhaps the excitement about photography—which was still a very new art and which, like early American painting, concentrated at first almost entirely on portraiture—is the cause.

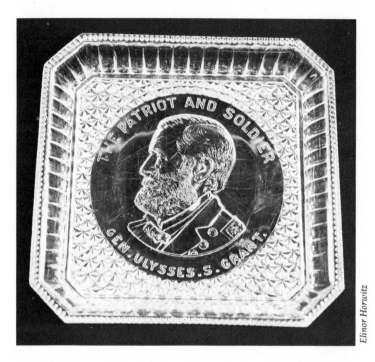

General Ulysses S. Grant bread plate. Ca. 1885. Courtesy Sandwich Glass Museum, Sandwich, Mass.

Elinor Horwitz

No man or woman has risen to fame in this century without becoming the subject of an American-made doll, and Charles Lindbergh was no exception. Lindbergh made his historic flight across the Atlantic in 1927 and in the excitement of the time was seen not only as an intrepid and skillful aviator, but as a living symbol of the ingenuity and daring that to most romantics typified America. The Lindbergh doll is missing a few parts—the aviator helmet, the hands and feet—but the confident boyish grin is intact. The Douglas MacArthur doll, who stands near Lindbergh in a museum on Cape Cod, gives a snappy salute from his display shelf. Like Lindbergh, MacArthur later lost the admiration of many of his most ardent fans, but during World War II he was unquestionably a hero of

Charles Lindbergh doll.
Courtesy Yesteryears Museum,
Sandwich, Mass.

General Douglas MacArthur doll.
Courtesy Yesteryears Museum,
Sandwich, Mass.

first rank. Notice his prominent place of honor on the V for Victory quilt on page 34.

What is a patriotic folk hero? There is no generally accepted definition. Can a sports hero qualify? Eldren Bailey fashioned a large concrete figure of Hank Aaron hitting his 715th home run, because he considered him a hero worthy of standing in his sculpture garden with John F. Kennedy (see page 152) and Christ on the Cross. Martin Luther King and, to a less visible extent, Robert Kennedy have been mourned—in painting and carving, on plates, hangings, and posters—by artists of the 1960s and 1970s. It's difficult to consider either man a patriotic folk hero, however. King has come to symbolize not his nation, but the timeless, universal quest for racial equality and brotherhood.

Hank Aaron. This figure, made of cement, was completed by plaster worker Eldren Bailey of Atlanta, Georgia, on the night Aaron hit his record-breaking 715th home run.

Elinor Horwitz

King and Kennedy. Bob Mayhew. This double portrait was painted on the outside wall of a house in Washington, D.C.

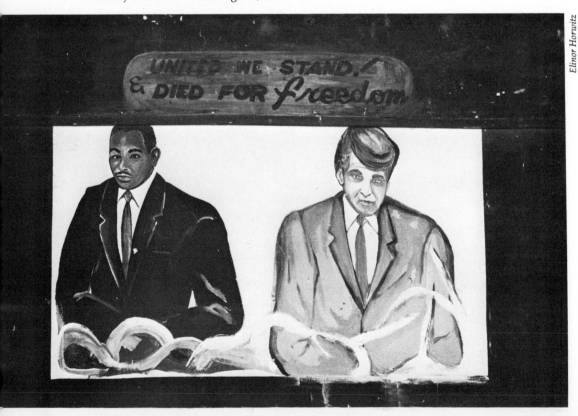

UNITED WE STAND.
& DIED FOR *freedom*

Elinor Horwitz

Expert quilter Mary Borkowski of Dayton, Ohio, has stitched portraits of presidents and themes from the history of Ohio and of the country on her totally original pictorial quilts. In the quilt below, which she has named Our American Heritage, she pays an expert needlewoman's tribute to every one of the presidents of the United States. A portrait of Gerald Ford has been added since the photograph was taken.

"Our American Heritage" quilt. The faces of all the American presidents were hand stitched by quilt maker Mary Borkowski of Dayton, Ohio.

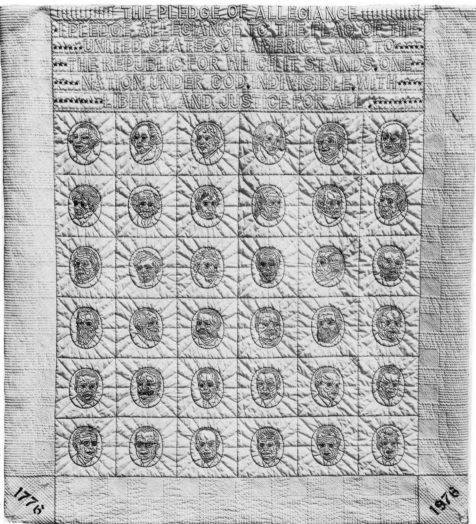

Perhaps the only way to distinguish a patriotic folk hero from the great roster of men and women who are admired for their particular talents and contributions or for outstanding qualities of mind and spirit is this. A patriotic hero is someone who makes us proud of our country and of being Americans. There is no question about the fact that for most people in this country the following four men eminently qualify.

Eighteenth Century: George Washington

No one else in the history of this nation received such veneration from his fellow countrymen as our first president. The solemn, somewhat detached respect most of us feel today for the Father of Our Country bears no relationship to the passionate admiration bestowed by his contemporaries. A veritable cult of Washington worship developed at the time of the Revolution and continued after his death and on through most of the nineteenth century.

One result of this intense public devotion was the desire on the part of just about everyone to own and display the first president's likeness. The most distinguished painters and sculptors, fully aware of the fact that their work might prove immortal, devoted themselves to the noble chore of painting his portrait; humble whittlers, with heartfelt dedication, carved rude likenesses for their own delight; engravers, glassmakers, potters, sign painters, tinsmiths, and other artisans knew that anything decorated with the image of George Washington would be snatched up by an insatiable public. As our early crafts society became increasingly industrialized, the bustling market for Washingtoniana continued unabated, resulting in a wide variety of manufactured items.

During the Revolutionary War and the period of his presidency Washington was the subject of portraits by twenty-seven professional painters and sculptors. No man in history has ever been so frequently portrayed from life. Charles Willson Peale painted the first official portrait in 1772. Later, during Washington's first term in office, Peale returned with his artist daughter and two artist sons. They circled the patient president and sketched for hours. Gilbert Stuart, who, along with Peale, had studied at the studios of the greatest painters of the day, executed three different portraits of Washington from life and then lived wealthily ever after painting close to one hundred replicas to meet the burgeoning demand. Until recent years a photographic reproduction of one of these

116

General Washington on a White Charger. Ca. 1830. Courtesy National Gallery of Art, Washington: Gift of Edgar William and Bernice Chrysler Garbisch. This painting by an unknown American artist shows Washington gallantly lifting his hat. See similar portrayal of Andrew Jackson, page 110.

portraits hung in nearly every American public school. In 1785 the French government sent their most distinguished sculptor, Jean Antoine Houdon, to America to make a portrait. Over a century later his bust of Washington became the model for the first president's image on stamps and coins. It is interesting to note that the 1900 silver dollar with Wash-

ington on one side and Lafayette on the other was the first American coin to bear a portrait of one of our presidents.

America's first two academic sculptors were alive during Washington's presidency. William Rush of Philadelphia modeled the president from life and in 1814 used his clay model as the basis for a greatly admired wood carving. Architect-sculptor Samuel McIntire of Salem, Massachusetts, sat attentively in a window when Washington visited Salem to speak from the balcony of the courthouse. He sketched the eminent visitor with great care and later carved several profile plaques from his drawings. This one, made in 1805, was installed on the gateway of Salem Common.

George Washington.
Carved relief.
Samuel McIntire. 1805.
Courtesy National Gallery
of Art, Washington. Index
of American Design.

Of course few people actually saw the president himself or even the original paintings and carvings. Popular engravings based on skillful realistic portraits satisfied the demand for pictures of the first president. There were more than twenty copperplate engravers turning out paper prints in the colonies before the Revolution and their number increased in the late eighteenth and early nineteenth century. French and English engravers also produced inexpensive etchings of Washington for interested buyers in Europe and America. The British potters, who were particularly sensitive to the commercial appeal of the subject, made great numbers of mugs and pitchers featuring Washington's image. At the time of his inauguration his impassive face appeared on mugs bearing the legend LONG LIVE THE PRESIDENT OF THE UNITED STATES. Soon after his death in 1799 a best-selling Liverpool pitcher labeled APOTHEOSIS showed the president being lifted to heaven by angels (page 10). The reverse bears the legend WASHINGTON IN GLORY, AMERICA IN TEARS.

Another popular British export was this drapery fabric, which shows Washington riding at the head of the troops in a chariot drawn by

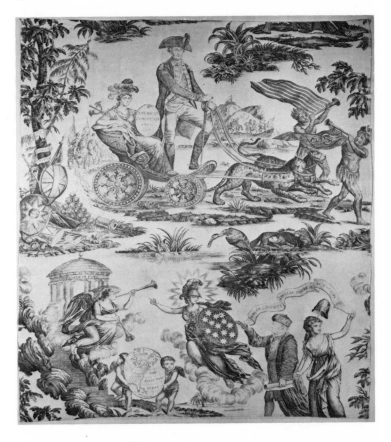

The apotheosis of Washington and Franklin. English printed textile. Ca. 1800. Courtesy DAR Museum, Washington, D.C.

leopards and escorted by Indian lads blowing trumpets. Revolutionary War flags decorate the trumpets and Washington's companion is a Liberty figure in Indian headdress who carries a shield marked AMERICAN INDEPENDENCE. The chariot has just passed a clearly marked liberty tree. Below the chariot Benjamin Franklin and another Liberty figure bearing a pole and cap wave a banner saying WHERE LIBERTY DWELLS THERE IS MY COUNTRY. The figure of Washington was copied from an engraving by Valentine Green based on a 1781 painting by artist John Trumbull.

When Washington died an atmosphere of profound national mourning resulted in an enormous output of memorial pictures and samplers, paintings and engravings of Washington in battle, scenes of Mt. Vernon and of the president's grave. This memorial painting by an anonymous American folk artist shows a leggy, tightly ringleted Liberty figure and a strange Asiatic-looking attendant, presumably a slave, mourning by

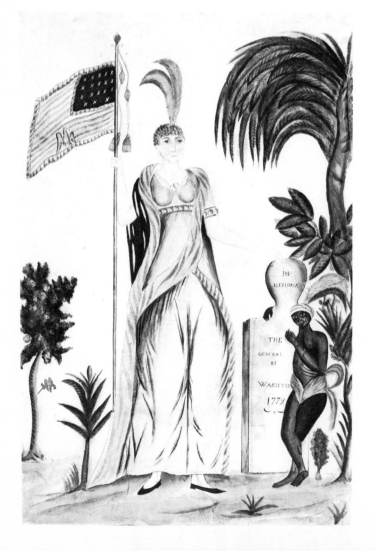

Memorial to General Washington. Watercolor. Ca. 1815. Courtesy Phila-delphia Museum of Art: Edgar William and Bernice Chrysler Garbisch Collection.

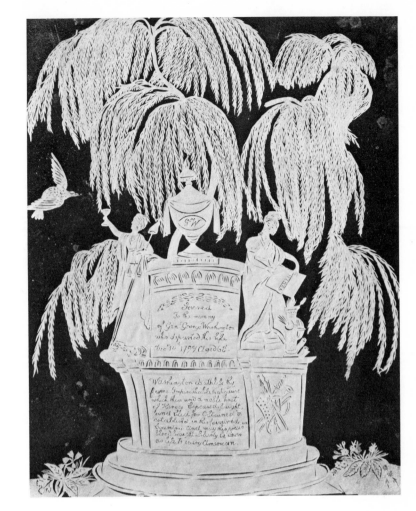

Papyrotamia Washington memorial. White cut paper against a mirror. Ca. 1815–1820. Courtesy DAR Museum, Washington, D.C. This is one of many depictions of Liberty offering drink to the eagle derived from the Savage engraving on page 79.

Washington's grave. The grave seems to have been relocated in the tropics, the flag is more decorative than accurate, the president's name is misspelled, and the date of his death is incorrect by twenty years—but there is no question about the fact that the painter was genuinely moved by the poignancy of his vision.

Paper cutting was a favorite art of the eighteenth and nineteenth centuries. This delicately scissored grave scene shows a monument topped by the newly popular motif of a Grecian urn. A large weeping willow forms an effective backdrop for the monument and its two Grecian goddesses. One goddess, who can be identified as Liberty by her pole and cap, offers a goblet of water to a bald eagle, another variation on this familiar theme. She tramples the British crown underfoot. Her companion, ignoring the national bird, browses in a book titled TRUTH.

Printed textiles were already being made in this country at the time of Washington's death. One handkerchief designed as a souvenir of the

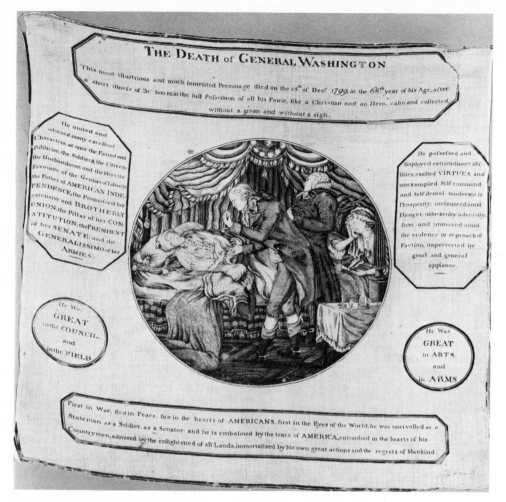

Handkerchief. Sepia print on linen. 1799–1800. Courtesy DAR Museum, Washington, D.C.

shattering event shows Washington on his deathbed with his wife grieving at the foot and Doctors Craik and Dick in attendance. The grim rendition of the shrunken dying man in his nightcap appealed to a rugged populace accustomed to facing unromanticized deathbed scenes.

Despite the fact that Washington was the object of nationwide admiration in the nineteenth century, an amazing number of oddly unlike, unflattering, and even undignified images were made. The figurehead of a young Washington draped in the manner of the classical revival is scarcely recognizable. These andirons show a peculiarly pudgy Washington. Other manufactured items of metal include cookie cutters, garden figures, and a rather forbidding stove figure from the 1840s—a

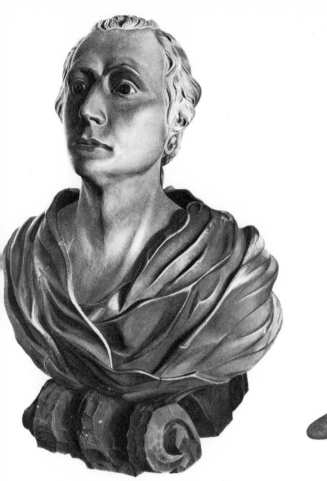

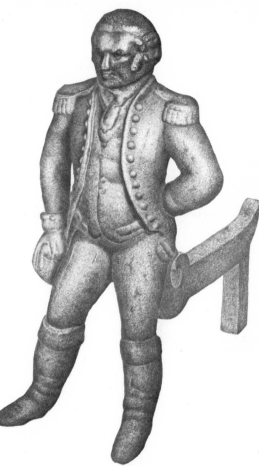

George Washington. Carved figure-head. Courtesy National Gallery of Art, Washington. Index of American Design.

Andiron. Courtesy National Gallery of Art, Washington. Index of American Design.

hollow casting which fills up with hot air from the stove and functions as a radiator.

From the time of the War of 1812 until the twentieth century, George Washington appeared repeatedly on glassware. When glass manufacturers started using full-size piece molds instead of blowing each piece freely, the first of sixty different Washington bottles made its debut. In pressed glass there were Washington cup plates and tea plates. An early tea plate features an awkwardly drawn profile of the first president and an astonishing error on the part of the mold cutter, who skillfully patterned his leaves and acorns but reversed the president's names. He

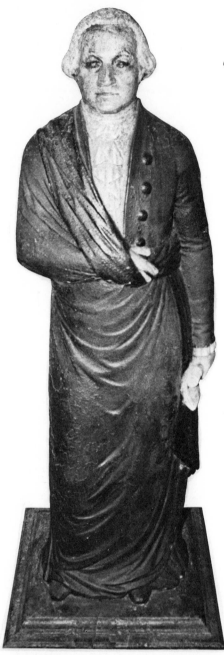

Heating stove figure of Washington.
Painted iron. Patented by A. L. Blan-
chard, Albany, New York, 1843. Cour-
tesy Smithsonian Institution.

Elinor Horwitz

probably was illiterate and became confused copying the letters. Al-
though the plate is thought to have been made as a memento of the
centennial of Washington's birth, the error was not corrected. A num-
ber of these WASHINGTON GEORGE plates still survive.

*Whiskey flask portraying George Washington.
Privately owned.*

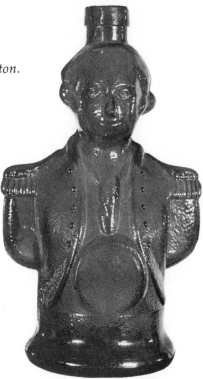

Joshua Horwitz

*"Washington George" platter. Ca. 1832.
Courtesy Sandwich Glass Museum, Sand-
wich, Mass. This plate, on which the mold
cutter reversed the names, was probably
made for the centennial of Washington's
birth.*

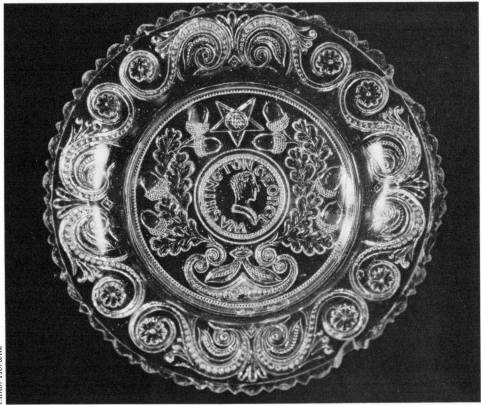

Elinor Horwitz

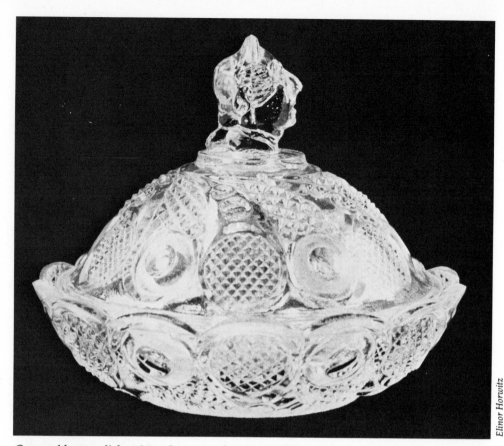

Elinor Horwitz

Covered butter dish. 1860. Courtesy Sandwich Glass Museum, Sandwich, Mass. The "horn of plenty" glass pattern was inspired by Halley's comet. The reason for combining it with a finial in the shape of a head of Washington is less clear.

This covered butter dish, made in 1860, is in the "horn of plenty" design inspired by Halley's comet, produced at the Sandwich Glass factory and several other glassworks. The finial of the lid is the disembodied head of the Father of Our Country.

As Washington worship continued unabated, busy lithographers, including the famous team of Currier and Ives, brought the president's face and scenes of Revolutionary War battles to parlor walls all over the country. Folk artists fashioned their own renditions. Needlepoint portraits of Washington, based on popular prints, were the pride of artistically inclined housewives. This version of Gilbert Stuart's "Lansdowne" portrait of Washington was made in the Civil War period. A more freewheeling adaptation of the same portrait by Stuart is a banner, in

George Washington. Needle-point. Louise Cook Roth. Ca. 1861–1865. Reproduced through the courtesy of the New York State Historical Association, Cooperstown. This is a needlepoint version of Stuart's "Lansdowne" portrait of Washington.

which the fine interior has been replaced with a background of army tents. It is thought to have been made on the occasion of the centennial of either the Declaration of Independence or Washington's inauguration.

William Matthew Prior, one of the most famous of the itinerant limners of the nineteenth century, was also an admirer and copier of Stuart's work. Very little is known about most of these self-taught portrait painters who traveled about seeking customers, but Prior's life and work are relatively well documented. He was born in 1806 in Bath, Maine, the son of a shipmaster who was lost at sea when the artist was ten years old. In his teens, Prior went to work as a decorative painter and portrait artist. Although he had no formal training, he advertised his skills in the *Maine Inquirer*—painting, bronzing, varnishing, drawing of all types of machinery, and decorating tea trays "in a very tasty style." Later he advertised himself as a portrait painter, charging ten to twenty-five dollars for portraits in gilt frames which he made himself. This was

higher than the going rate at that time, and presumably he already had some reputation for his skill.

Prior had long admired Stuart's work and even named his oldest son Gilbert Stuart Prior. In 1850 he sought permission of the authorities at the Boston Athenaeum to make a copy of their Stuart portrait of Washington. Afterward, he made many copies of this painting on glass, which he sold for three to four dollars each.

Prior was an extraordinarily skillful copyist. Other folk artists of the nineteenth century left portraits with less realistic detail but with great vigor and vitality. A delightful woodcarving of Washington and his

Washington banner. Reproduced through the courtesy of the New York State Historical Association, Cooperstown. This banner, painted on cloth, was found in Moorefield, West Virginia. Like the needlepoint piece, it was based on Stuart's "Lansdowne" portrait of Washington.

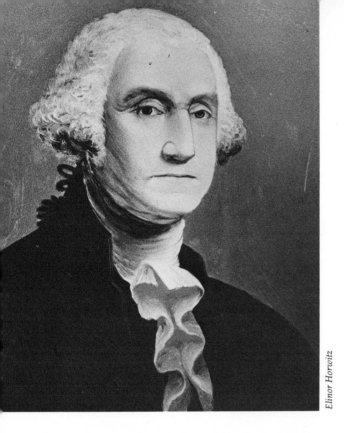

George Washington. Reverse painting on glass. William Matthew Prior. 1850. Courtesy American Folk Art Shop, Washington, D.C. This painting was copied from the Stuart "Athenaeum" head of Washington.

Elinor Horwitz

horse (page 71) was found in the whaling town of New Bedford, Massachusetts, and is thought to have been carved at sea. A number of scrimshaw portraits of Washington also survive. The crude woodcarving is unusual because of the flag carved on Washington's shoulder. In style it resembles "chalkware" of the period—cast plaster figurines made in Pennsylvania.

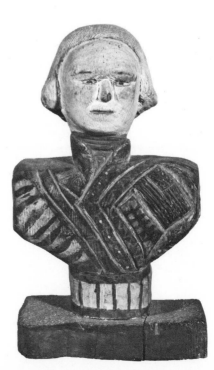

George Washington. Wood. Pennsylvania German. Courtesy Abby Aldrich Rockefeller Folk Art Collection, Williamsburg, Va.

This simple late-nineteenth-century whirligig once turned its arms with every breeze, gladdening the heart of the creator. It is one of the few folk art portraits of Washington from the period after the Civil War.

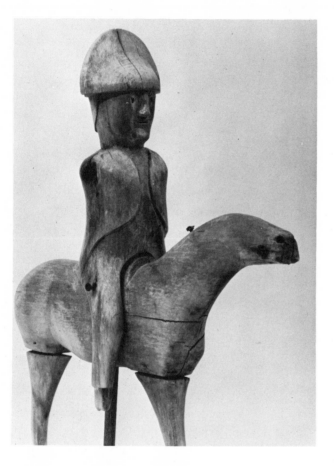

George Washington whirligig. Late nineteenth century. Collection of Michael and Julie Hall.

Interesting twentieth-century depictions of Washington are scarce. Somehow, after the upheaval of the Civil War, the first president began to seem a remote figure. It was not simply a matter of time. The war had brought a change from the boundless optimism about the future of America that was so intimately associated with the figure of the first president. Although engravings and later photographic reproductions of Washington portraits continued to adorn homes and schoolrooms, folk artists seem to have lost interest in the eighteenth-century gentleman in his powdered wig. The most amusing twentieth-century Washington "portrait" may well be this large mascot figure which represents the basketball team of George Washington University in Washington,

D.C. At game time a student in colonial costume dons the head and dances around with the cheerleaders in an unmistakably twentieth-century fashion.

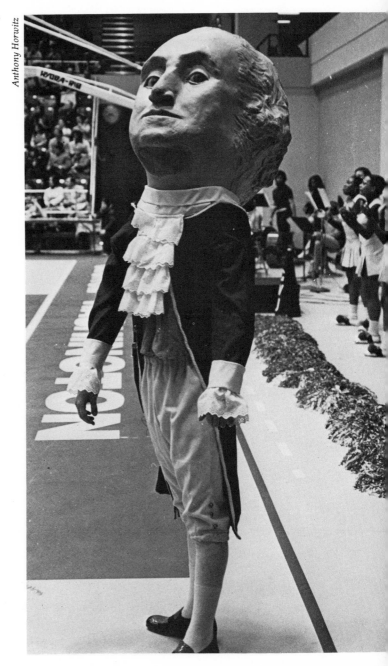

George Washington University mascot. This large plastic head of Washington is worn by a student in colonial dress as part of the cheering section during basketball games.

In 1932, on the two hundredth anniversary of the first president's birth, a host of cheap souvenirs hit the market. Frank Moran, a self-taught New England carver, honored the event in his own way. He carved this angular youthful figure with large head, tiny hands and feet, spindly legs, rigid posture, and intense expression. The Washington figure is a fine folk carving, but it somehow fails to speak to us about the man himself. Later Moran did a considerably larger and more human portrait of Lincoln. A number of folk artists who have attempted both Washington and Lincoln portraits have failed with the former. As one folk artist explains, "Washington happened too long ago. It's just hard to get close to him. Lincoln is different. He still moves us."

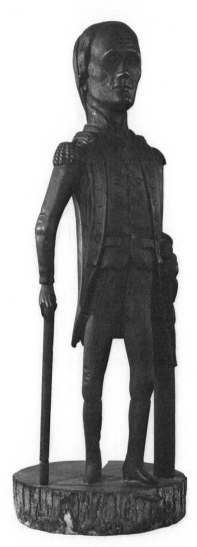

George Washington.
Wood. Frank Moran. 1932.
Reproduced through the courtesy of the
New York State Historical Association,
Cooperstown.

Nineteenth Century: Abraham Lincoln

In the hearts and minds of most Americans, George Washington occupies a special lofty place. The patrician first president, with his ill-fitting teeth, impenetrable expression, and historical-pageant clothing, has become a thoroughly honorable and honored, estimable and esteemed, rather unapproachable figure. What did he look like without his wig? Did anyone ever see him laugh? Did anyone ever see him cry?

Everyone knows Lincoln laughed . . . and cried . . . and sometimes spilled soup on his tie. Although during his lifetime he never received

Campaign bandana. 1864. Courtesy Smithsonian Institution. Lincoln's candidacy was "endorsed" by George Washington.

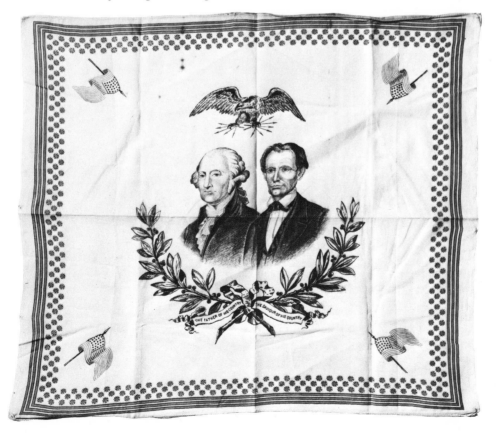

the virtually universal admiration granted Washington, he is revered today as a patriotic hero—and also deeply loved as a leader and as a man. Visitors to Washington, D.C., admire the tall silhouette of the Washington Monument, but they tarry to weep at the Lincoln Memorial.

The homespun figure who became president at such a difficult period in our history has been—for over a century—a potent source of inspiration to folk artists who are moved by his ideals, by his humble origins, by his wit, his courage, his sufferings. Since he lived in the age of photography and popular journalism, people everywhere saw pictures of their president. Although few heard his voice—which is reported to have been surprisingly high-pitched—everyone recognized the figure of the tall, gaunt man with the sensitive, brooding expression.

Since most folk art representations are undated, it's difficult to know whether pieces such as the jaunty little carving of a beardless Lincoln were made during his lifetime or after his death. The figurehead was unquestionably made in 1861 for the ship *Abraham Lincoln*. It shows the president delivering his inaugural address—to the dolphins and the gulls. Lincoln's head, like Washington's, appeared on many late-nine-

"Columbia I Love Thee Still." Cartoon. 1864. Reproduced through the courtesy of the New York State Historical Association, Cooperstown.

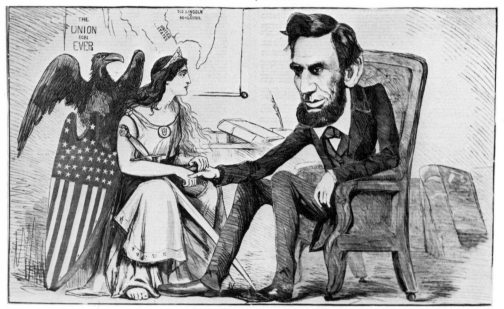

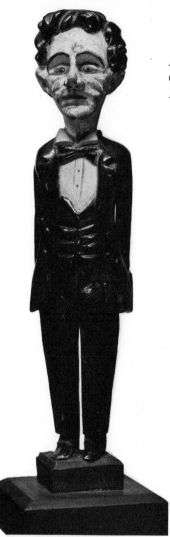

Abraham Lincoln. Painted wood.
Courtesy Museum of Fine Arts, Boston:
M. and M. Karolik Collection.

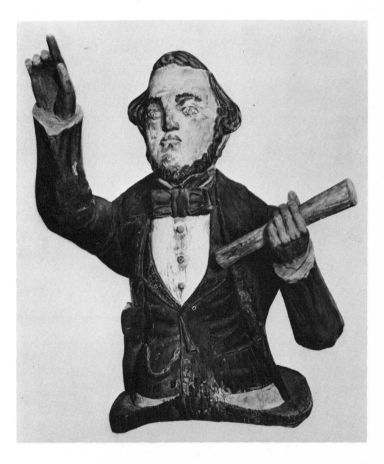

Figurehead from ship Abra-
ham Lincoln. *1861. Cour-*
tesy National Gallery of
Art, Washington. Index of
American Design.

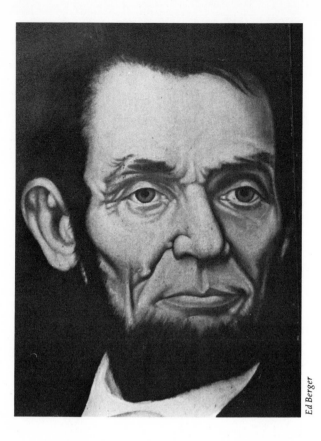

Abraham Lincoln. Oil on breadboard. Ca. 1875. Privately owned. This portrait was probably a copy of a Mathew Brady photograph.

Ed Berger

"The News from the Front Looks Good." Cartoon. 1865. Courtesy Smithsonian Institution: Ralph E. Becker Collection. This cartoon by the most famous of all American cartoonists, Thomas Nast, appeared in print on the day Lincoln was shot.

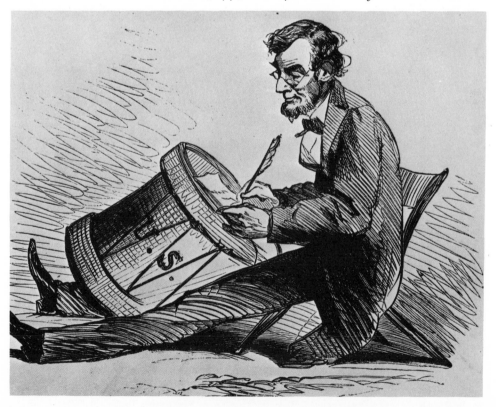

teenth-century glass flasks and on a wide range of other types of glassware. This bold portrait, which was painted on a breadboard, may have been made during his lifetime. It was probably copied—quite expertly—from a well-known portrait by the Civil War photographer Mathew Brady.

By the time of the Civil War, the allure of the photographic portrait was so intense that Erastus Salisbury Field, a well-known limner from the Connecticut River Valley area of Massachusetts, began to suffer from the competition. In this extraordinary painting he grouped Lincoln, Burnside, Grant, Hayes, and Arthur and posed them the way a photog-

Lincoln with Washington and His Generals. Erastus Salisbury Field. Courtesy Museum of Fine Arts, Springfield, Mass.: Morgan Wesson Memorial Collection. The generals (left to right) are: Ambrose E. Burnside, Ulysses S. Grant, Rutherford B. Hayes, and Chester A. Arthur. Washington bestows his blessings on the troubled president.

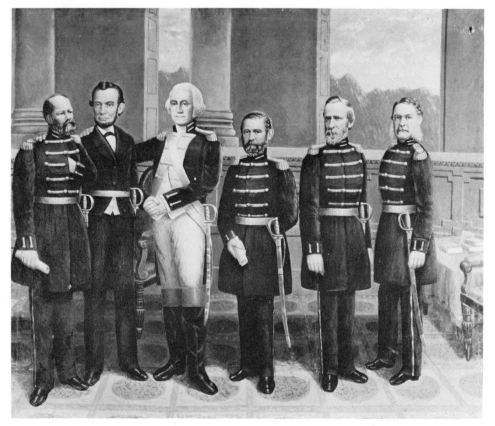

rapher of the period would have found suitable. He then inserted into the stiff realistic painting something extra that the photographer could not have provided. The spectral figure of George Washington stands next to Lincoln, offering sympathy and assuring him that everything will turn out well.

After his death Lincoln appeared in memorial portraits of every sort. He was frequently shown paired with Washington, as he had been during his political campaigns and as he continued to be in the twentieth century (page 71). The curious hooked rug with the letters of

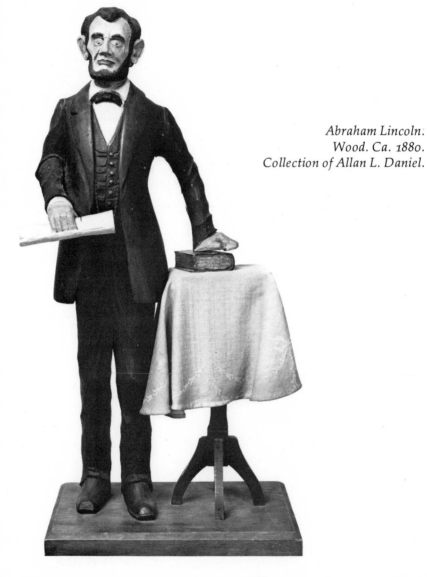

Abraham Lincoln.
Wood. Ca. 1880.
Collection of Allan L. Daniel.

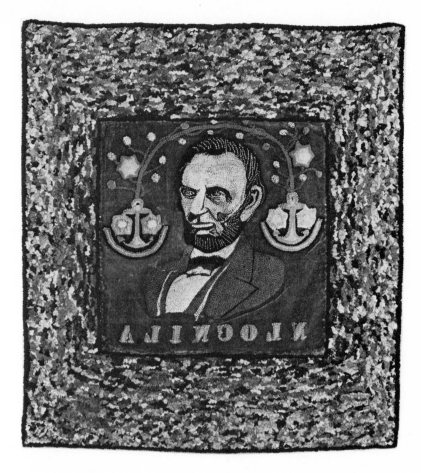

Hooked and embroidered rug. Ca. 1865. Courtesy George E. Schoellkopf Gallery, New York, N.Y.

his name reversed was made shortly after his death. It is an example of an old folk tradition which prescribes that the name of a person who has recently died be indicated in this fashion. The custom appears in other cultures as well as in our own.

Lincoln has continued to inspire folk painters and carvers, who seem to feel a compelling urge to express their emotional attraction to the president who has now been gone for over a century. A virtually life-size carving of Lincoln, hewn from a large tree trunk, was made by William Norris of Virginia, Illinois, who fashioned all the details with a simple pocketknife. Real buttons decorate the coat and the shirt. The eyes are emphasized by a coating of shellac.

Another very large carving, also cut from a single log, is Frank Moran's sensitive youthful Lincoln. The seated posture may have been inspired by the Daniel Chester French carving made for the Lincoln Memorial in Washington. Moran, who was born in 1877 on a farm in northern Vermont, was a woodworker and cabinetmaker. After separating from his wife and four children, he moved back to his family farm alone. He was known as an unambitious man, a heavy drinker, a soli-

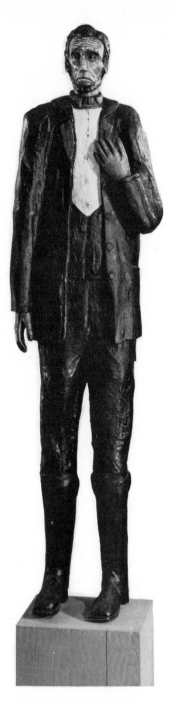

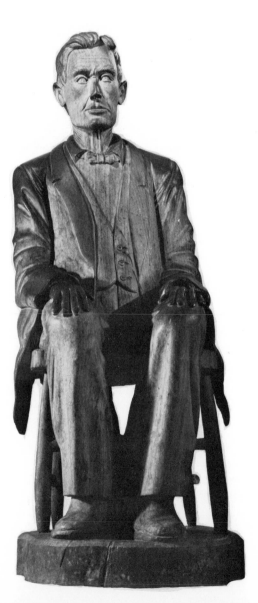

Abraham Lincoln. Painted wood. William Norris. 1938–1939. Courtesy Abby Aldrich Rockefeller Folk Art Collection, Williamsburg, Va. This almost life-sized figure (over 71 inches) has real buttons on the coat and the shirt. The expressive eyes are coated with shellac.

Abraham Lincoln. Frank Moran. Ca. 1940. Reproduced through the courtesy of the New York State Historical Association, Cooperstown. This large (54-inch) seated figure, like Norris's Lincoln, was carved from a large tree trunk.

tary fellow who lived without heat, electricity, or plumbing and carved figures of people he admired out of wood. In 1932 he made a figure of Washington (page 132). He also did smaller carvings—of Winston Churchill, of Joseph Stalin, of Eleanor Roosevelt.

In 1940 he carved his monumental Lincoln, and although he gave away most of his work to people who brought him groceries and drove him to town, he kept the Lincoln in his small house until he died in 1967. It was known to be his favorite, and it stayed by the potbellied stove, near his favorite seat. People who knew Moran felt that Lincoln was his companion and that he talked to the figure during the long days and nights. One side of the pine carving is scorched from the heat of the stove.

Folk art depictions of Lincoln continue to appear. Ed Ambrose of Stephens City, Virginia, carved Lincoln making his address at Gettysburg. L. G. Wright, a builder of wooden oyster boats in the Chesa-

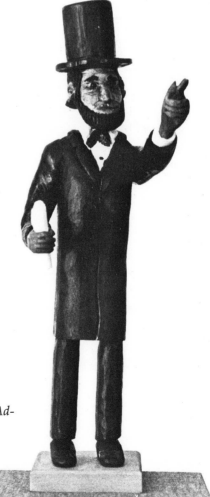

Abraham Lincoln Delivering the Gettysburg Address. Painted wood. Edward Ambrose. 1975. Collection of Cathy-Jo and Bill Brockner.

Elinor Horwitz

peake Bay area of Virginia, has a sign on his building saying BOATS BUILT AND PAINTINGS PAINTED. Presidents are his favorite subjects and his portrait of Lincoln is one of his most successful.

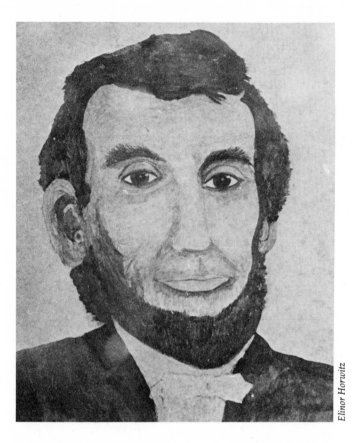

Abraham Lincoln. L. G. Wright. Collection of Jeffrey T. Camp. Wright is a builder of wooden oyster boats for use in the Chesapeake Bay. He has painted portraits of a number of presidents.

Elinor Horwitz

Thomas Jefferson Flanagan of Atlanta, Georgia, is a former railroad mail clerk who for several decades rode the Southern Railroad from Charlotte to Atlanta. Now in retirement, he paints portraits of members of his family and of people he admires. He has made a fine Kennedy portrait (page 151) and several sensitive paintings of Abraham Lincoln. Flanagan has no problem talking about his attraction to Lincoln. "Every time I paint him I think about his life and about those sad, sad eyes. Look at those eyes."

Malcah Zeldis, of Brooklyn, New York, also paints from a strong personal attachment to the figure of Lincoln. She was emotionally moved by a Mathew Brady photograph of Lincoln sitting outside his tent on a battlefield, and felt compelled to paint her own boldly patterned inter-

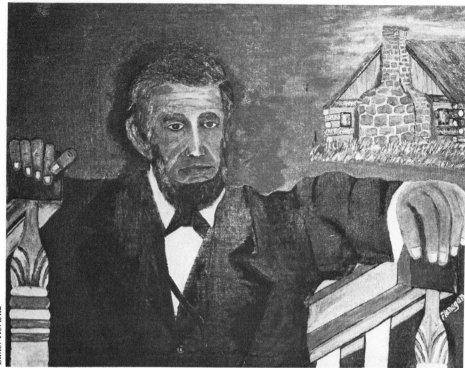

Abraham Lincoln. Thomas Jefferson Flanagan. Flanagan, a retired railway mail clerk, has made several Lincoln portraits. This one shows Lincoln's birthplace in the distance.

Abraham Lincoln Outside His Tent. 1975. This painting is one of five views of Lincoln visiting the battlefields painted by Malcah Zeldis of Brooklyn, New York. They were all inspired by the same Mathew Brady photograph.

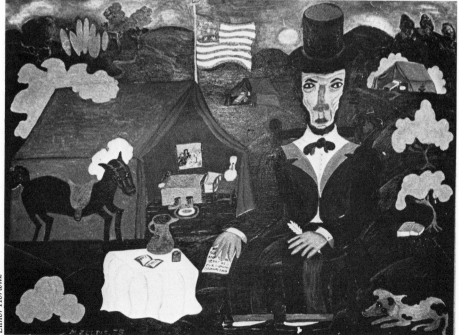

pretation of the scene. Zeldis, a self-taught artist, is struck by the gentleness and strength, the pain and sensitivity she finds in the face of the president, whose image returns compellingly to her mind. She has painted the scene five times.

The president fondly remembered as "Old Abe," as "Honest Abe," as the rail-splitter who was born in a backwoods cabin in Kentucky, was referred to by statesman John Hay, who wrote his biography, as "the greatest character since Christ." Perhaps the judgment was extravagant. Perhaps it was not.

Twentieth Century: Theodore Roosevelt and John F. Kennedy

The names may look strange juxtaposed in the title of a chapter, but among the twentieth-century presidents only these two men, Theodore Roosevelt and John F. Kennedy, became genuine patriotic folk heroes.

Like Lincoln, neither one lacked political opponents. Kennedy was elected president by the narrowest popular margin of any man in the twentieth century. Roosevelt was such an avid social reformer and such an unpopular choice for vice-presidential candidate among party politicians that G.O.P. national chairman Mark Hanna asked with alarm, "Don't any of you realize there's only one life between this madman and the White House?" The prophetic question was often recalled by conservative opponents in later years. But both these men, who grew up in surroundings of wealth, status, and privilege, managed to capture the loyalty and love of Americans of all economic and social levels. Both were seen as embodiments of the youthful vigor of a free nation that had survived bloody wars and severe social and economic disruption—and was now, once again, on the move.

Roosevelt and Kennedy came to the presidency at extraordinarily early ages. Theodore Roosevelt was a forty-two-year-old vice-president when he rose to office in 1901 as the result of the assassination of President William McKinley. John Fitzgerald Kennedy was forty-three in 1960—the youngest man to be actually elected to the presidency. Both came to power after weary old soldiers vacated the post. The buoyant, colorful young Roosevelt followed a president who was noted for his taciturn ways and conservative views. McKinley was the last of the Civil War

veterans to achieve high public office, a man unprepared to face the dynamic changes of turn-of-the century America. Kennedy arrived on the scene after Dwight David Eisenhower—who was a reluctant president, a tired father figure, most admired for his role as a general in World War II.

People who had little interest in the powers of the presidency or the implications of industrial expansion adored President Theodore Roosevelt, who brought an almost explosive vitality to the office. He was a man of varied talents and experience—the leader of the Roughriders, the hero of the Battle of San Juan Hill, a hunter, a scholar, a progressive New York reformer. Having been frail, asthmatic, and timid as a child, he had built himself up by conscious strenuous effort and he extolled the rewards of physical fitness. When his first wife died two days after the birth of their daughter, Alice, in 1884, he left the political fray and sought release from sorrow in the strenuous physical life of ranching in the Badlands of South Dakota.

He remarried in 1886, and came to the White House as the exuberant father of a large and lively household whose antics were reported daily in the newspapers. The president enjoyed having pillow fights with his

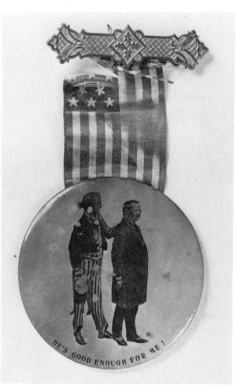

"He's Good Enough For Me!" Election badge. 1904. Courtesy Smithsonian Institution: Ralph E. Becker Collection. Uncle Sam himself offered Roosevelt his blessings.

sons. His regal-looking daughter slid down the White House banisters. Pet animals of all sorts scampered through the historic rooms—and the public read about it and loved it. The president, who spoke his feelings freely and with gusto, was quoted in newspapers and magazines in 1903 assuring his devoted public, "I *enjoy* being president."

For recreation, Roosevelt sparred with John L. Sullivan in the White House gym. He took time off to hunt panthers in Colorado. Young people reveled in the news that he performed push-ups at six o'clock each morning, took fifty-mile hikes, rode horseback, organized football games with friends on the White House lawn. Unhindered by social precedent, he invited Booker T. Washington to dinner. This was the first occasion on which a black man was a guest at the White House.

He refused to shoot a young bear cub on a hunt, and soon America's favorite toy was the "Teddy Bear." Not long afterward, the bear named for the president appeared in songs and stories. Popular books for children wove tales about the little "Teddy" bears, the bears spared by the humane president's rifle.

The easily caricatured face of Roosevelt in his pince-nez spectacles

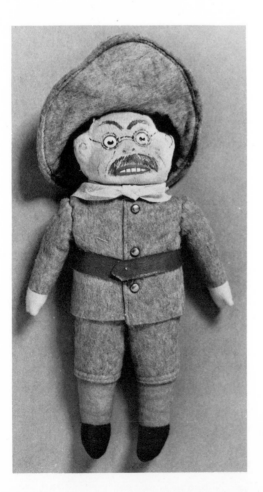

Theodore Roosevelt doll.
Courtesy Smithsonian Institution.

appeared in folk paintings, on dolls, on Toby jugs and pipes, in newspaper cartoons—even on whirligigs such as this one. In a contemporary

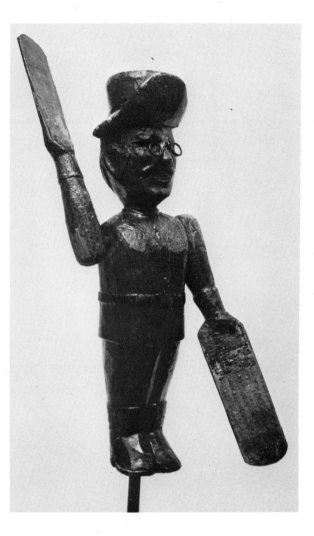

Theodore Roosevelt whirligig. Painted wood. Ca. 1913. Collection of Michael and Julie Hall.

portrait by Dow Pugh of eastern Tennessee (page 148) he grins cheerfully, with all the toothy vitality for which he was celebrated.

Many admirers praise his "square deal" program—an interrelated succession of social reforms. But most important to folk artists is the man himself—the revered Roughrider—a man with immense energy and an infectious zest for life; a man who carried a high-powered rifle and a big stick but who loved romping with babies. A relative, commenting on the president's zest for center stage, said with resignation, "When

147

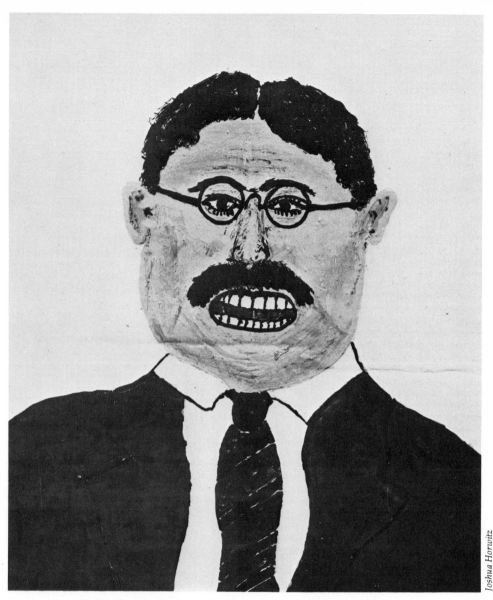

Joshua Horwitz

Teddy Roosevelt. Dow Pugh. 1972. Collection of the author.

Theodore attends a wedding he wants to be the bride, and when he attends a funeral he wants to be the corpse.''

When John Fitzgerald Kennedy was elected thirty-fifth president in 1960 he was the first Catholic to be elected to the office and the first president born in the twentieth century. At his inauguration he said, ''Let the word go forth from this time and place, to friend and foe alike, that the torch has been passed to a new generation of Americans—born

in this century, tempered by war, disciplined by a hard and bitter peace, proud of our ancient heritage."

The love affair with the public had begun. Although he had been voted into office by a narrow majority, Americans from coast to coast were fascinated with the dynamic, idealistic young president and the entire Kennedy clan. "Jack and Jackie" were worshiped by people of widely varying political persuasions who were dazzled by the attractiveness, intelligence, glamour, and charm of the new first family. When the boyish-looking World War II hero lauded physical fitness, high school students and bank presidents took up jogging. When the first lady appeared on television or in the newspaper wearing the latest creation of a famous designer, wealthy women of fashion and low-income working girls and housewives hastened to imitate her style. The doings of the president's parents, brothers, sisters, brothers-in-law, sisters-in-law, and nieces and nephews were followed avidly by the daily press. When the Kennedys revealed that their favorite game was touch football the sport acquired a chic aura no one could have foreseen.

J.F.K. Dow Pugh. Courtesy John Rice Irwin's Museum of Appalachia, Norris, Tenn.

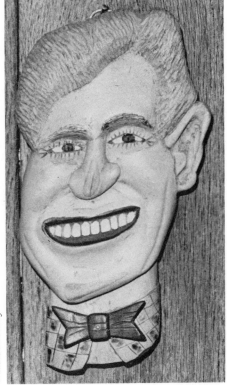

Wallace E. Denny

Kennedy's political decisions will continue to be evaluated and reevaluated, but the memory of his personal charisma is vivid and indisputable in the minds of most Americans. During his administration White House social gatherings seemed to glitter with more beautiful people, beautiful music, and witty conversation than at any former time. His "New Frontiersmen" seemed more brilliant and youthful and glamorous than any previous presidential advisors. And yet the president himself always remained a movingly human and vulnerable man in the eyes of even the least privileged Americans. The personal tragedies and losses that visited his enormously talented and attractive family were sincerely mourned by men and women of all levels of wealth, education, and sophistication. When Kennedy was assassinated people here and around the world felt—beyond their shock and horror—a profound sense of personal loss which endured long after the initial period of grief.

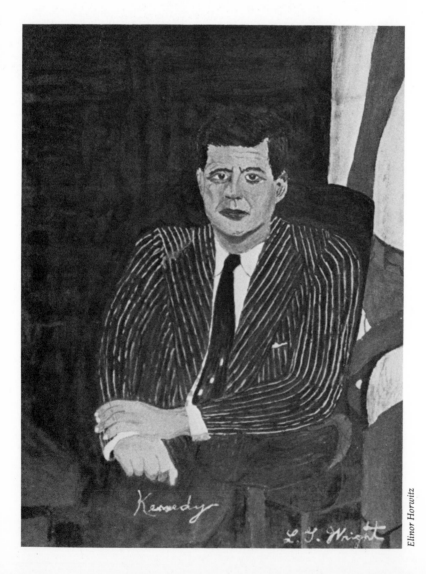

John F. Kennedy.
L. G. Wright.
Ca. 1963.
Collection of
Jeffrey T. Camp.

Elinor Horwitz

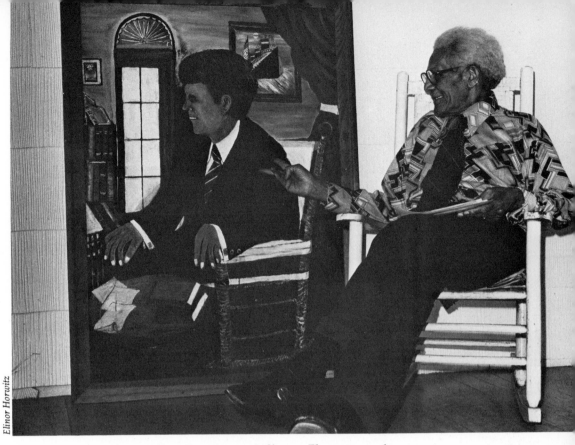

John F. Kennedy. Thomas Jefferson Flanagan. 1963.

Folk artists were compellingly interested in Kennedy all through his administration. After his death loving portraits in all media were made by men and women who passionately yearned to keep his memory fresh. Thomas Jefferson Flanagan based his large painting of his beloved president on a photograph of an official portrait of the president seated in his famous rocking chair. Eldren Bailey, who also lives in Atlanta, has been a plasterer for thirty-two years. On the day of the assassination, he conceived the idea of making a Kennedy memorial in cement. "I just wanted something right here in my yard to remember him by," he says.

Angela Palladino of New York City was born in Italy. She says of her painting of Kennedy and Mussolini in their coffins, "Look, Mussolini is saying, 'It's terrible what happened to you. I understand. It was the same with me. You try for yourself. I try for myself. Here we can talk about it.' "

Justin McCarthy is a self-taught octogenarian artist who made a commemorative painting of the Kennedys in the White House (page 153) one year after the assassination. Jacqueline Kennedy appears to be dressed

151

Elinor Horwitz

Kennedy memorial.
Cement.
Eldren Bailey.
1964.

C. Michael de

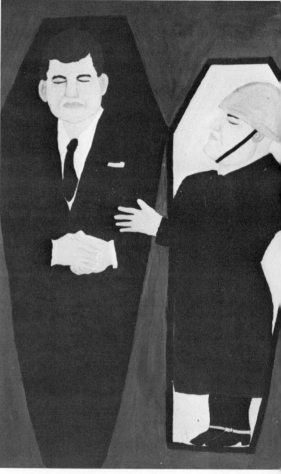

The Great Meeting.
Angela Palladino.
1966.
Collection of
Herbert W. Hemphill, Jr.

Mr. and Mrs. John F. Kennedy. Justin McCarthy. 1964. Collection of Mr. and Mrs. Sterling Strauser.

N. F. Karlins

in the pink suit she wore the day of the disaster. Due to television and press coverage of Mrs. Kennedy's arrival in Washington with the president's casket, most Americans who were teenagers or adults in 1963 vividly remember the macabre sight of the chic first lady's bloodstained skirt.

The televised funeral of John F. Kennedy was watched by virtually everyone in the country. Marshall Fleming, a West Virginia carpenter, watched carefully and soon afterward made a large (forty-two-inch-long) model of the Kennedy caisson. Each wooden horse is equipped with leather saddle, reins, and stirrups. The tails and manes are made of coarse string. Above the caisson Fleming has placed a plaque displaying photographs of the four assassinated presidents. The famous riderless black horse, with the empty boots in the stirrups turned backward, walks alongside the procession.

Daniel Patrick Moynihan, then assistant secretary of labor, corrected columnist Mary McGrory when she said at the time of the Kennedy assassination that the slain president's friends would never laugh again. "Heavens, Mary. We'll laugh again," he protested. "It's just that we'll never be young again."

Moynihan repeated the remark on television and across the country.

Kennedy caisson. Marshall Fleming. Collection of Mr. and Mrs. J. Roderick Moore.

People without his gift for graceful expression felt that they too had lost a beloved friend and that Moynihan was echoing their own intensely personal response. Today Kennedy's status as a patriotic folk hero remains intact, and men and women continue to find in their passionate devotion to our martyred youngest elected president a compelling source of artistic inspiration.

Patriotic Heroes in Action

It would be a sin of omission to conclude a book on patriotic imagery without some mention of the prevalence in both folk and popular art of recreations of historical scenes. Eyewitnesses to great events have left verbal accounts; men and women who sit at home with paints, canvases, needle and thread have enriched the descriptions with their own imaginings and produced unique portrayals of historic moments.

Esther McGrew Hardin of San Antonio, Texas, is a prolific and extraordinarily gifted needlework artist who has made any number of appliquéd and embroidered hangings based on legends and events in American history. She has shown Betsy Ross at work on the flag (page 70), the blazing of the Oregon Trail, Johnny Appleseed, the joining of the transcontinental railway with the golden spike, homesteaders in the west. In her picture of Valley Forge titled The Winter of Despair she has portrayed the wretched soldiers huddled by the fire, nursing their bleed-

ing feet. The flag marks Washington's headquarters. Mrs. Hardin, an ardent saver of outgrown clothing and shopper at remnant sales, has made the snow on the ground from a white T-shirt and the snow on the roofs from an old white sock.

In her portrayal of Paul Revere's Ride (page 72) Revere leaves from Boston's Old North Church. "That's artistic license," she says. "Actually, he first rowed across the Charles River and then started his ride,

The Winter of Despair. Appliquéd and embroidered picture. Esther McGrew Hardin. 1975. Courtesy Fendrick Gallery, Washington, D.C.

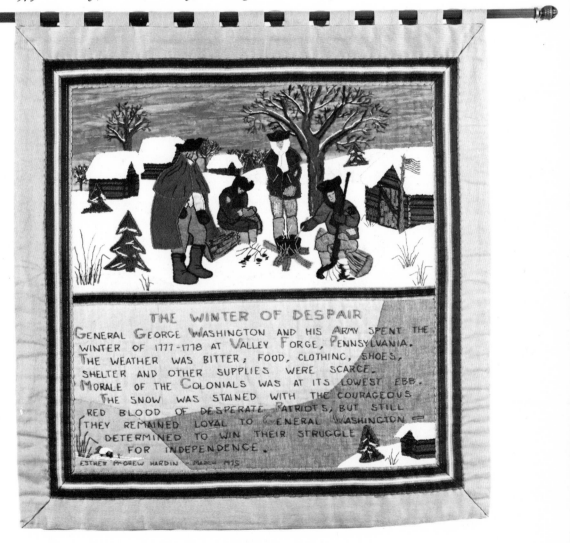

but I couldn't show all that in one picture." She points out the people who have been aroused by the night riders and the clock in the tower, which reads five minutes after twelve.

Revolutionary War battles have inspired more folk art than the conflicts of any other war. Reuben Law Reed, whose ancestors had fought at Bunker Hill, was a nineteen-year-old house painter when he painted Washington and Lafayette at the Battle of Yorktown. The two generals ride stiffly side by side viewing the marching men and the bursts of shellfire. On the right a line of cavalry prepares to charge.

Like folk art, popular art has recorded significant moments in our history. Lithographs of historic scenes were produced in large editions all through the nineteenth century. The most famous were those put out by Currier and Ives.

Nathaniel Currier started his print business in 1834 and was joined by James Merritt Ives in 1852. The innovative aspect of their work was their pioneering use of color. At that period color illustrations were virtually unknown. The firm of Currier and Ives kept an assembly line of women,

Washington and Lafayette at the Battle of Yorktown. Reuben Law Reed. Courtesy Abby Aldrich Rockefeller Folk Art Collection, Williamsburg, Va.

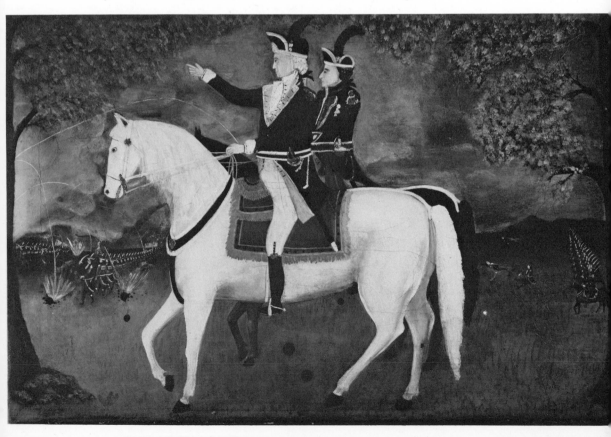

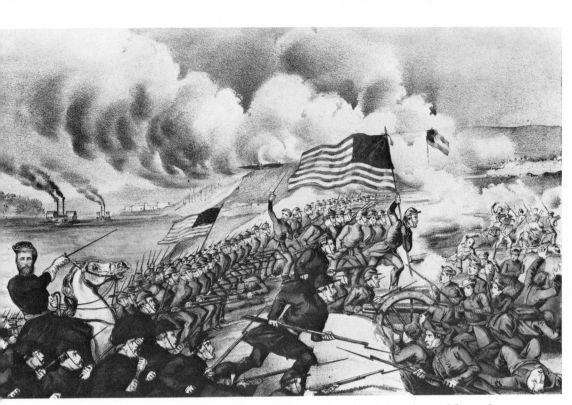

"The Storming of Fort Donelson, Tenn., Feby. 15th, 1862." Currier and Ives. Courtesy Museum of the City of New York: Harry T. Peters Collection.

working at wages of less than one cent per copy, hand-painting the black and white lithographs as they came from the stone. In 1860 the enormously successful firm issued a catalog offering 738 different hand-colored scenes and 218 black and white lithographic prints at prices ranging from 8 cents to $3.75. The subject matter embraced political cartoons, and pictures of historic scenes, ships, railroads, the Wild West, hunting and fishing, boxing, horse racing. Thousands of lithographs of pretty, rosy-cheeked children, perfectly shaped fruits, and lavishly tinted flowers were made for Victorian parlors. Their battle scenes were crammed with men, gunfire, horses, swords, corpses. They chronicled—with considerable historical inaccuracy—engagements of the Revolutionary War, the War of 1812, the Mexican War, and the Civil War. With advances in color lithography and photography the demand for their work decreased, but today Currier and Ives prints are highly treasured by collectors.

Folk art and popular art renditions of historic scenes have been inspired not only by the historic moments themselves, but also by "fine

157

art" interpretations. One of the most famous paintings of an episode in American history is Emanuel Leutze's Washington Crossing the Delaware. Leutze painted at least four canvases of the scene, but the version with which everyone is familiar is a huge (140-inch by 256-inch) painting made in 1851 which belongs to the Metropolitan Museum of Art in New York. No academic work, with the exception of Gilbert Stuart's portraits of Washington, has inspired so many folk art interpretations. A Currier and Ives lithograph based on the painting takes considerable liberty with the details of Leutze's work, pitching the sharp diagonal line of the flagpole forward, rather than back, and decreasing the number of men in the boat and changing their positions. Photographic reproductions of the painting were widely available in the later nineteenth century and folk artists seem to have adhered more closely to the original than did Currier and Ives.

Two meticulously embroidered versions are of interest. The American piece, with flat doll-like men and boats that look like toys, has many of the characteristics of primitive portraits. The Japanese embroidered picture is more faithful to the original. After the Civil War, works of this sort were frequently commissioned by individuals or organizations. A photograph of the Leutze painting was sent to the Orient, where expert

Washington Crossing the Delaware. Emanuel Gottlieb Leutze. 1851. Courtesy Metropolitan Museum of Art: Gift of John Stewart Kennedy, 1897.

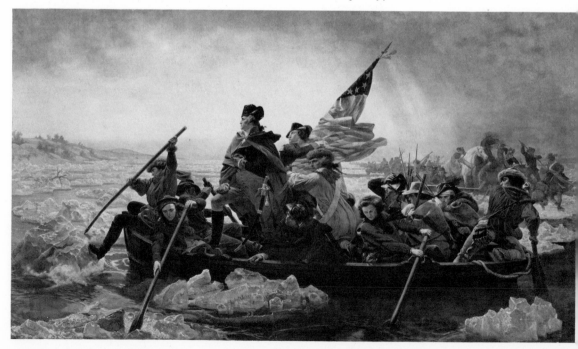

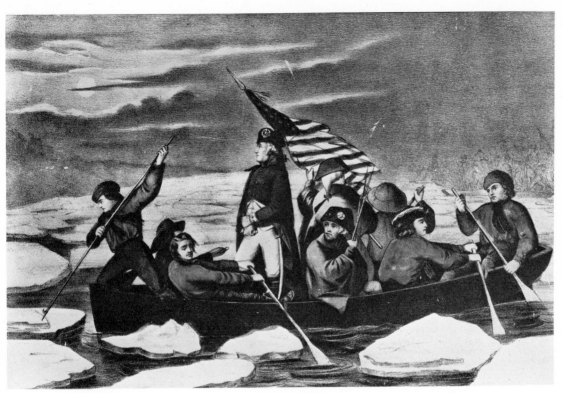

Washington Crossing the Delaware, December 25, 1776. Lithograph by Currier and Ives. Courtesy Museum of the City of New York: Harry T. Peters Collection.

Washington Crossing the Delaware. Embroidered picture on silk. Ca. 1880. Reproduced through the courtesy of the New York State Historical Association, Cooperstown.

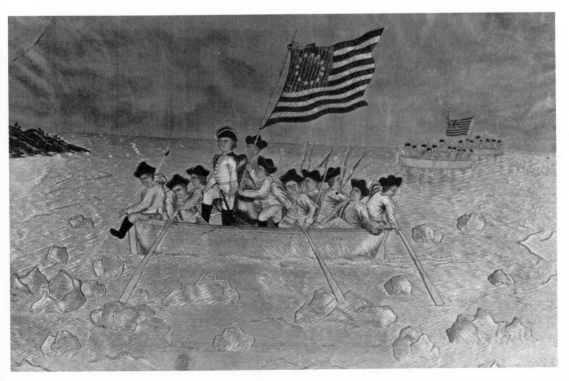

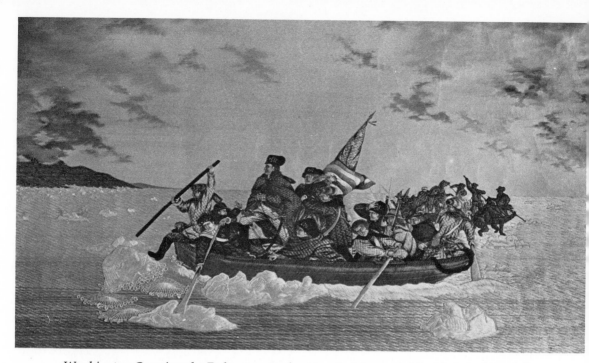

Washington Crossing the Delaware. Embroidered picture on silk. Made in Japan. Ca. 1870. Collection of the author.

needleworkers transformed it into an embroidered picture with a seascape suggesting Japanese prints and clouds delicately painted on a silk sky. The faces of the Revolutionary War soldiers have a distinctly Oriental cast.

The three painted versions vary considerably from one another. The nineteenth-century work by an unknown American painter conveys the tension of the men as they row through a brilliant green river. Justin McCarthy of Weatherly, Pennsylvania, who raises and sells vegetables, has been painting for five decades. His version of the crossing, also based on Leutze, is marked by bold brushwork that emphasizes the drama of the scene. Malcah Zeldis, who has painted Lincoln many times (see page 143), had no success with an attempted portrait of Washington, which she says looked "like a colored postcard." But her interest in the scene of the daring crossing resulted in the vivid interpretation on page 72. She also credits the Leutze painting as the source of her idea.

Although battle scenes of the past still interest folk artists, the wars of the twentieth century have been chronicled by photographers, who have brought us scenes that evoke more horror and despair than exhila-

160

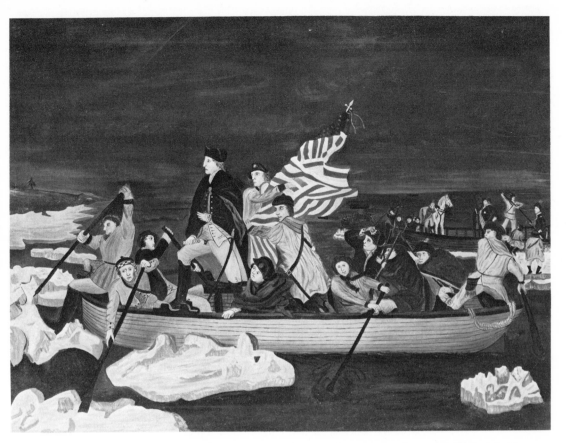

Washington Crossing the Delaware. Late nineteenth century. Courtesy Philadelphia Museum of Art: Edgar William and Bernice Chrysler Garbisch Collection.

Washington Crossing the Delaware. Justin McCarthy. Ca. 1963. Collection of Herbert W. Hemphill, Jr.

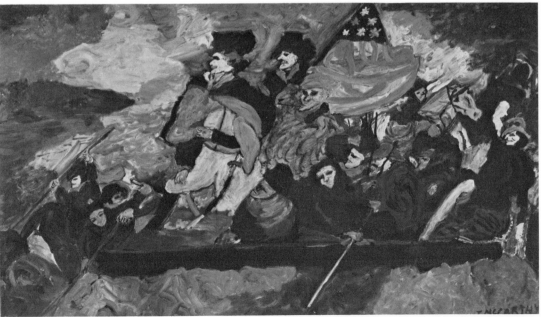

ration. Contemporary folk artists have shown little interest in the realities of wars which occurred during their own lifetimes.

Today the unquestioning and boundlessly optimistic patriotic fervor of nineteenth-century America may seem out of date, naive, a type of tunnel-vision chauvinism that many people today view as unenlightened—even dangerous. And yet, the desire to express love of country, or disapproval of political events, or concern for the future of the nation—in a drawing, a painting, a carving, a piece of needlework—persists. Men and women who still find a source of inspiration in the cherished symbols of nationhood are continuing to add to our rich legacy of patriotic folk art.

Hail Columbia!

Suggestions for Further Reading

Bishop, Robert, *American Folk Sculpture*. New York: E. P. Dutton & Co., 1974.

Christensen, Erwin O. *Early American Wood Carving*. New York: World Publishing Co., 1952.

Fried, Frederick. *Artists in Wood*. New York: Clarkson N. Potter, 1970.

Grafton, John. *The American Revolution: A Picture Sourcebook*. New York: Dover Publications, 1975.

Hemphill, Herbert W., Jr., and Weissman, Julia. *Twentieth Century American Folk Art and Artists*. New York: E. P. Dutton & Co., 1974.

Hornung, Clarence P. *Treasury of American Design*. New York: Harry N. Abrams, 1972.

Isaacson, Philip M. *The American Eagle*. Boston: Little, Brown and Co., 1975.

James Montgomery Flagg Poster Book, The. Introduction by Susan E. Meyer. New York: Watson-Guptill Publications, 1975.

Ketchum, Alton. *Uncle Sam, The Man and the Legend*. New York: Hill & Wang, 1959.

Klamkin, Marian. *American Patriotic and Political China*. New York: Charles Scribner's Sons, 1973.

Klapthor, Margaret Brown. *Official White House China: 1789 to the Present*. Washington, D.C.: Smithsonian Institution Press, 1975.

Lipman, Jean. *American Folk Art in Wood, Metal and Stone*. New York: Dover Publications, 1972.

Mastai, Boleslaw, and D'Otrange, Marie-Louise. *The Stars and the Stripes*. New York: Alfred A. Knopf, 1973.

Pinckney, P. A. *American Figureheads and Their Carvers*. New York: W. W. Norton & Co., 1940.

Pratt, John Lowell, ed. *Currier and Ives: Chronicles of America*. Maplewood, N. J.: Hammond, 1968.

Welsh, Peter C. *American Folk Art from the Eleanor and Mabel Van Alstyne Collection: The Art and Spirit of a People*. Washington, D.C.: Smithsonian Institution Press, 1965.

Index

ELINOR LANDER HORWITZ has been a free-lance writer since her graduation from Smith College. She is a frequent contributor to the *Washington Post,* has written for many national magazines, and is the author of a number of books for young and adult readers. She and her husband, neurosurgeon Norman Horwitz, live in Chevy Chase, Maryland. They have three children.

J. RODERICK MOORE has a master's degree in American Folk Culture from the Cooperstown (New York) Graduate Program. After a variety of jobs, including stints as a coal miner, an apple picker, and an apprentice gunsmith, he turned to research and teaching. Mr. Moore has served as archivist, coordinator, and consultant for numerous folk life and folk art projects and has contributed articles on related subjects to several journals. He is currently on the faculty of Ferrum College, Ferrum, Virginia, where he is Associate Director of the Blue Ridge Institute.